DIALOGUE
RELATIONSHIPS
IN GRAPHIC
DESIGN

SHAUN
COLE
V&A
PUBLICATIONS

First published by
V&A Publications, 2005

V&A Publications
160 Brompton Road
London SW3 1HW

Distributed in North
America by Harry N.
Abrams, Inc., New York

ISBN 1 85177434 3

Library of Congress Control
Number 2005923376

V&A Publications
160 Brompton Road
London SW3 1HW
www.vam.ac.uk

Designed by
Graphic Thought Facility

Printed in Italy

DIALOGUE
RELATIONSHIPS IN GRAPHIC DESIGN

AUTHOR BIOGRAPHY

Shaun Cole is Curator of Contemporary Programmes at the V&A Museum, specializing in fashion and graphic design. He has curated a number of exhibitions and events including Graphic Responses to AIDS (V&A, 1996), Dressing the Male (V&A, 1999), five innovative Days of Record and Black British Style (V&A, 2004). His publications include 'Don We Now Our Gay Apparel: Gay Men's Dress in the Twentieth Century' (Berg, 2000).

ACKNOWLEDGEMENTS

My grateful thanks are due to all the designers, agents and clients who generously shared their time, information and thoughts and who also supplied images. I would also like to thank the following people for their help in making Dialogue possible: Jane Pavitt for her encouragement and advice; Mary Butler and Monica Woods at V&A Publications; Krystyna Mayer for editing the text; Graphic Thought Facility for designing the book; the Contemporary team, especially Susan McCormack and Lauren Parker at the V&A, for support, advice and suggestions; Ann Gelbmann for additional research; David White; John Green; and Andrew for his constant encouragement and support.

SERIES FOREWORD

Design is an essential component of everyday life, in ways that are both apparent and imperceptible. But who are the authors of the things that surround us? What drives the thinking behind the development of new products? From cutting-edge experimentation to the re-styling of mass market goods, designers leave their imprint in a diversity of ways. They shape the objects with which we furnish our homes, the tools with which we communicate and the environments in which we live, work and play.

The V&A has played a role at the heart of design culture since it was founded in 1852. Part of its mission was a commitment to the under-standing of contemporary design, and this mission remains true today. The V&A now embraces all aspects of design in contemporary life, from fashion, graphics, photography and digital media to craft, architecture and product design.

The V&A Contemporary series explores the designer's role in shaping products of all kinds – from the one-off to the mass produced, from objects in three dimensions to digital environments. The series celebrates creativity and diversity in design now, highlighting key debates and practices, and confronting us with questions about the future of our designed world. Each title takes a critical and informed look at a parti-cular field, built around interviews with designers and commentaries on selected products and projects. We hope these studies encourage us all – designers and consumers alike – to look with fresh insight at the objects and images around us.

Jane Pavitt, Series Editor

INTRODUCTION: RELATIONSHIPS IN GRAPHIC DESIGN

GRAPHIC DESIGN IS THE MOST VISIBLE OF ALL FORMS OF DESIGN. IN WHAT WE BUY AND READ, ON OUR SCREENS, SHELVES AND STREETS, IT SURROUNDS OUR EVERYDAY LIVES.

It is a fast-growing industry. Graphics and advertising form the largest sub-discipline of design in the United Kingdom, which also has the highest number of graphic design higher education courses (362 in 2003) in Europe. Worldwide, the profession is supported by a network of professional organizations; these form ICOGRADA (the International Council of Graphic Design Associations), which has around forty-five member countries. Despite the predominance of multinational agencies that manage large branding and advertising accounts, many graphic designers are self-employed or work in small-scale independent studios.

The title of this book, **DIALOGUE**, reflects the fact that communication and collaboration are central to the processes and relationships within graphic design. The industry has evolved to support a wide range of jobs and roles, in addition to the most obvious one of creative designer sitting in front of a drawing board or computer creating work. The variety of roles and structures within contemporary design consultancies reflects the complexity of client and designer relationships. The 'creative', the 'planner' and the 'technician' may all have defined roles within a company and the projects it undertakes. Equally, a designer may have to assimilate all of these roles into his or her working practice in order to fulfill a client's need. Good dialogue between all the parties concerned, including clients, is essential to this process.

The range of work embodied by the discipline is now huge. As American designer DK Holland asserts, 'Graphic design [is] a discipline that has often defied description.'[1] The work of the graphic designer embraces all forms of visual communication – illustration, typography, advertising, surface design, images and text for print, screen and web interface. Tibor Kalman has said, 'It's [also] a mode of address, a means of communication.'[2] It is a vehicle for the expression of ideas as well as the promotion of services. As both a service to business and a means of creative expression, graphic design is at the intersection of the commercial and the cultural.

'RE–' MAGAZINE
Cover, issue 6
Designer: Jop van Bennekom
2001

The graphic design community is as diverse as the work it produces, ranging from multinational brand strategists to one-man font foundries. The designers included in this book are representative of that range: they include self-employed independents like Amsterdam-based Jop van Bennekom, large consultancies such as Coley Porter Bell and advertising agencies like BBH London.

Graphic design is also a process, employing skills, tools and specific languages and visual devices. The introduction of the Apple Macintosh computer in 1984 revolutionized the practice of graphic design. It changed a labour-intensive, skilled profession that relied on the professional expertise of printers, lithographers, typographers and typesetters to one that allowed for more of this work to be done by one person using one machine. Inevitably, with the increasing sophistication and capabilities of the Macintosh and new software, the need for traditional skills and professions began to disappear. However, by the turn of the new millennium many designers were lamenting the loss of the emotion and spirit that could be experienced from traditional techniques both as a process and in the end product.[3] For some this meant a move away from the computer back to traditional hand-made methods, but for many more, such as Paris-based Olivier Kuntzel, it allowed for a blending of techniques:

> Today we imagine the place like a kind of laboratory and we experiment with different things. We melt old and new techniques. We design by hand a lot and we try to introduce life into the graphic design. We don't want to turn to solely creating computer graphics. If a new technique can help we use it but we try to keep a little contact with the old style.

Many analyses of contemporary graphic design have concentrated on the relationship between the designer and the end user, and between the context and the message. Fewer have examined the relationships between designer and client, and the complexity of negotiation that occurs between first contact and final product. Based on conversations with designers, agencies and clients, **DIALOGUE** looks at the creative process that turns an initial brief into a successful end product.

RE–

Re-Magazine #6
From Amsterdam NL
Spring 2001
The Manic Issue
Hfl. 17,50 / 8 Euro

THE
INFORMATION
TRASHCAN

Page 1 continues on page 2.

LEVI'S TYPE 1 JEANS
First scamp
Agency: BBH London
Art directors/copywriters:
Dean Wei and Joseph Ernst
Client: Levi Strauss
2003

Understanding graphics means under-standing the complex nature of working practices. Designer and educator Lorraine Wild explains the kind of information needed to do this: 'Explicit information about the communications, the chain of command, the schedules, the budgets, the strategies, the presence (or absence) of marketing, the documentation...'[4] With the help of actual case studies, **DIALOGUE** explores the working methods and processes that designers undertake to create their 'products'. It considers a variety of projects undertaken by a range of designers. Within each case study it considers the relationship between client and designer, the briefing process, and the constraints or limitations of the brief, as well as how the set-up of a particular studio or agency impacts upon how the work is undertaken.

For each type of end product within graphic design, from posters to film graphics and corporate identities, there are particular factors that need to be considered. Every proposal that is presented to a designer has its limitations, be they financial, physical, time or legal, or a combination of these factors. It is the ability of the designer to work within these constraints or to overcome them and produce an end product that marks out a piece of graphic design as 'successful'. The size of the budget, for example, can determine whether or not a designer will agree to undertake a project, but equally can provide the designer with a challenge. Working within the cultural field particularly often places a tight budget upon projects. According to Dutch designer Anthon Beeke, 'Money is always the "X" of course. I'm not a money hunter, so there are a lot of possibilities you can do with money. When the client is open with his budget then we can play with it.'

The majority of work created by graphic designers is in response to a brief from a client. Michael Johnson, founder-director of London-based Johnson Banks, describes his work as 'finding interesting, imaginative solutions to other people's interesting problems'. Fellow British designer Derek Birdsall took Johnson's description a step further when he noted that 'as designers we are just here to please the client'.[5] While this may be true, and is often the relationship that a client requires from a designer, client/designer relations can be much more complex. American designer Maggie McNab identifies them as far more symbiotic. 'As in all yin-yang scenarios, we need each other to exist. Clients need the edge that makes them appear different and better than their competition; we need our design work to be recognized for its creative value. It keeps us both in business.' [6] Such a mutually beneficial relationship requires an understanding between client and designer of what is required to achieve a successful conclusion. As far back as the 1950s British designer Misha Black (1910–77) observed that '[w]hen the client and the designer are in sympathy, they can together produce better work than that of which either alone would be capable'.[7]

There is a very diverse range of clients, from small, non-profit organizations to large multinational corporations. Each designer or studio has certain qualities and approaches it looks for in its clients. 'What we look for are people who value what we do and know what we can bring to the relationship and want to contribute and believe,' says David Lightman, Business Development Manager at London design agency Coley Porter Bell. 'So the ideal client would believe in us, be committed to the project and want to work in a collaborative, interesting way.'

Many commentators have raised the question of the designer's quest for a 'perfect' client. Designer and writer Michael Bierut believes that it is 'something less rational than the simple good design/good business equation' that dictates a 'perfect client'. He argues that the factors that motivate good clients may be 'genetic rather than strategic' and they may in fact just be 'the kind of persons who like good design'.[8] Yet although many designers may have a series of criteria that they look for in a client, these may not always be found – so perhaps it is the perfect brief or project that designers should pursue.

One of the major concerns for designers engaged in client-based work is the balance between the client's message, and the stand that graphic designers take when it comes to the personal or social ethics involved in working for a particular client, or being party to the communication of that client's message.

FIRST THINGS FIRST
Poster released with the
'First Things First' manifesto update
from 'Adbusters',
July/August 2001
Designer: Jonathan Barnbrook
Text: Jonathan Barnbrook and Adbusters

AIRMAIL DRESS
Trials for graphic icons on dress
Design Group: Rebecca and Mike
Client: Hussein Chalayan
2002

Katherine McCoy, principal at American design company McCoy and McCoy and former professor at Cranbrook, is concerned that design graduates 'emerge as charming mannequins, voiceless mouthpieces for the messages of ventriloquist clients' and appeals for designers to be given 'their voices so they may participate and contribute more fully in the world around them'.[9] However, British designer Jonathan Barnbrook believes that the time of designers 'not having a moral position and just displaying the client's message' has now gone.[10]

It was these very concerns that led British designer Ken Garland to publish his **FIRST THINGS FIRST** manifesto in 1964.[11] Revised in 2001, the manifesto criticized designers and advertising for wasting a disproportionate amount of time and effort on 'trivial purposes which contribute little or nothing to our national prosperity'.

All designers undertake a process of questioning their own moral and ethical standpoints on clients and products, making personal (or company) decisions about what is right for them. They should always be, professor, designer and critic Michael Rock urges, 'conscious of the cultural effect of all products that pass through the studio'.[12] Such issues are extended into the way in which material is produced for clients, such as advising a client to use a particular paper or to produce information on a website instead of printing fifty thousand brochures. They also extend to the type of work produced. 'There are politics of good design,' says Mike Heath of London-based design duo Rebecca and Mike. 'That is our first political struggle, getting good design to the mass public. It is extremely unethical to churn out shit design just to get paid.'

There are many issues that determine the choices made by graphic designers when selecting clients. These can centre on a creative exchange between the designer and client, but may also be determined by a commercial imperative on the part of either party. For designers there are the questions of how they may invest in ideas, and whether working for free will allow them to explore creative avenues that they may not be able to explore with fee-paying clients.

Taking on free or pro bono work is ultimately a private decision, but it has caused debate within the graphic design industry. Austrian-born, New York-based designer Stefan Sagmeister, for example, does not undertake pro bono work but instead ensures that a third of his studio's work is done for socially relevant causes.[13] American designer Ellen Shapiro highlights how pro bono clients can 'set up all kinds of creative restrictions' and that it is 'often expected that photography, illustration and printing will be donated'.[14] Running alongside this is the designer's need or desire to build a reputation, and questions about the circumstances in which these reputations are gained.

Of course, there are projects where the relationship between client and designer creates the space for challenging and expressive work to develop. Bill Drenttel of Drenttel Doyle Partners in New York, in particular, has questioned the practice of undertaking pro bono work purely to win awards.[15] Designers may choose clients or projects where the impetus is ethical, personal or political as well as financial, but whatever the choice it is always rooted in the designer's own ethical code. American designers Milton Glaser and Stefan Sagmeister have a series of questions that they ask themselves when deciding whether to work for a client. These include 'How good is the product?' and 'How worthwhile are the client's activities?'[16]

One of the key methods of finding graphic design work is to pitch for projects. Essentially, this involves clients setting up competitions to find the best designer and solution for their job. Jethro Marshall, who operates as an agent pairing client briefs and designers, never creates competitions among his designers for work. According to him, 'It's not a fair thing to do, and hopefully by using someone like me, the client is actually bypassing a competition stage, because I am able to pick the right people for the right job. I know the designer's work, style and experiences – I should be able to match that with a client's needs.'

TRYING TO LOOK GOOD LIMITS MY LIFE
Design: Sagmeister Inc., New York
Art Direction: Stefan Sagmeister
Photo: Matthias Ernstberger
Client: Art Grandeur Nature, 2004

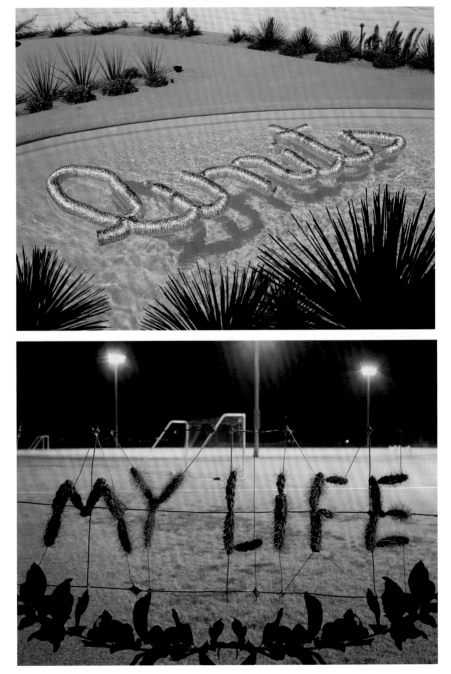

JAKE AND RHEA SCOTT WEDDING INVITATION
Design Group: Carter Wong Tomlin
Client: Jake and Rhea Scott
2003

There is a tradition among some design companies and advertising agencies to cold pitch – that is, send in ideas to potential clients. More usually the pitching process involves producing proposals for either an existing or new client in response to a specified brief. Often graphic designers are asked to pitch for free, an issue that is hotly debated within the industry. Many refuse, feeling that it is an abuse of their talents and time, and that it is immoral to take designers' ideas (the lifeblood of their work) and have them executed somewhere more cheaply. 'If you start giving your ideas away for nothing it's not good,' believes Phil Carter, Creative Director at London-based agency Carter Wong Tomlin. 'And it's not fair on the clients who are paying you if you have to take a team away to do that.' However much designers dislike the pitching process it is a reality, and it is inevitably much easier for well-known, established designers to refuse to pitch as they frequently have a core of clients. For younger, less established designers it is a way of getting work seen and their name known to potential clients.

Even when clients approach a designer to work for them it is not necessarily a given that the designer will get the job. There is still a process of negotiation to be undertaken, as Kerry Millet of London advertising agency Mother explains: 'You do still have to persuade them that a) you know what you are doing; b) you understand their market; c) you can do a better job than anyone else; d) you can work for the right kind of money, and e) you understand the process that you have to go through with them.'

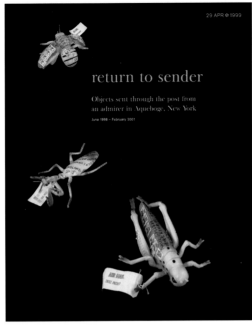

29 APR ✳ 1999

return to sender

Objects sent through the post from
an admirer in Aquebogue, New York

June 1998 – February 2001

**YOU CAN FIND INSPIRATION
IN EVERYTHING**
Single page
Design Group: Aboud Sodano
Client: Violette Editions
2002

For many graphic designers the establishment of long-term working relationships is fundamental to the running of their business. However, such partnerships are often not sufficiently financially rewarding to allow the studio to work exclusively on these projects. A range of work and clients must be found, and with each new client comes the inevitable gradual process of getting acquainted, as Alan Aboud of London-based Aboud Sodano observes, 'With a new client you've got this massive learning curve. It's about understanding how far you can push them, how far they want to go and understanding the way they work.' With existing clients these factors are reduced and it is more likely that the designers can respond more immediately to the brief rather than have to negotiate their way through questions about client behaviour and reporting structures.

In a global economy there is an increasing trend for clients to look beyond their local environment for a design studio to fulfill their needs, a practice facilitated by technological developments in the field of communication. This is often the case where major international clients are looking for a smaller studio that is defining itself as cutting edge. The client is looking for something that a particular designer offers in style or approach and is prepared to sacrifice a physical proximity for the benefit of a design approach. In a 'global' market it is possible for a small independent design studio to develop a high profile, and to resist the pressures to grow, but to work on significant international projects. The question for such studios remains how to retain the elements that make them attractive when they are being asked to work on large-scale projects.

GROW UP!: ADVICE AND THE TEENAGE GIRL, 1880s TO DATE
Poster
Design Group: The Chase
Client: The Women's Library
2003

In direct contrast to working at a distance, working with a local design studio that is able to respond in a more personal way can be a key consideration for clients. The success of a design company in a particular location can lead to expansion or diversification. After fifteen years in business, Manchester design consultancy The Chase set up a semi-independent branch in London that could pay closer attention to the particular needs of clients within the capital.

In an ideal world creativity and commerce should go hand in hand, but in practice there is often a compromise between creative freedom and commercial success – between projects that are economically successful and those that are undertaken for more altruistic reasons. Harriet Devoy, Creative Director of The Chase's London branch, compares finding the right balance of work to a well-balanced diet: 'You need the carbohydrates which may be big financial clients which pay the wages, but you also need the vitamins and minerals of smaller less well paid but exciting projects which allow you to take risks and be challenging.'

The client-led nature of most graphics-related work has led some critics to question the creative role of the designer. However, curator and designer Ellen Lupton has challenged the suggestion that the graphic designer fulfills a passive role of 'consulting, styling and formatting'.[17] Through self-initiated projects, designers are free to act as their own client, and to develop a distinctive visual style with which to convey their own point of view. Such work can put the designer in the role of author rather than copy-editor, creator rather than consultant. In this capacity a designer is free, Lupton observed, 'to create books, exhibitions, posters or magazines that are not dictated to by a clients requirements'.

6 FEBRUARY– 26 APRIL
MON–WED & FRI 9.30–5.30PM
THURS 9.30–8.00PM
SAT 10.00–4.00PM
ADMISSION FREE

THE WOMEN'S LIBRARY
LONDON METROPOLITAN UNIVERSITY
OLD CASTLE STREET E1 7NT
ALDGATE EAST ⊖

Don't start smoking at a party

practice at home first, you'll soon get the hang of it

GROW UP!
ADVICE AND THE TEENAGE GIRL
1880s TO DATE
AN EXHIBITION

THE WOMEN'S LIBRARY
celebrating and recording women's lives

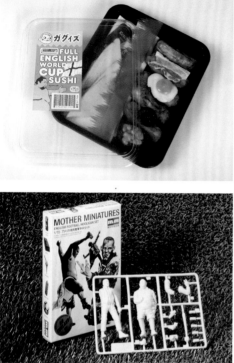

MOTHER FULL ENGLISH WORLD CUP SUSHI
Agency: Mother
Client: Mother
1999

MOTHER MINIATURES
Agency: Mother
Client: Mother
1999

It is also possible for the designer to develop a 'unique and recognizable visual penmanship'.[18] Design writer Natalia Ilyin has described how graphic designers need to feel that their work is individual, specific and inspired, but 'in a way that does not get knocked down at marketing meetings [...] restricted by a client's budget, and lack of vision'.[19] As well as stimulating creativity and exploration, such self-initiated work can enhance the personality of a company. It is easy for graphic designers to 'display their wares' by, for example, utilizing their skills to produce their Christmas cards, which act as a reminder and annual update brochure of their skills.

For London-based advertising agency Mother, their two annual self-initiated projects are important because they allow the agency to 'build our own brand not only with what we do for others but also for ourselves' (Cecilia Dufils, Creative). Self-initiated projects must, however, be balanced against fee-paying work, although they can feed into the process of other work or develop into commercially viable projects. The need to balance personal projects against fee-paying work may mean that they are done quickly and this keeps them more 'edgy'. Alternatively, some projects are allowed to gestate over a long period, drawing on other work and experiences and responding to developments in technology.

WINNEY
Design Group: Kuntzel + Deygas
Client: Baccarat crystal
2002–3

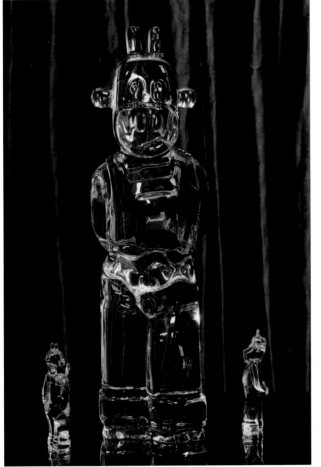

Graphic design is an open-ended practice that is by its very nature collaborative, and this is frequently the key to a successful piece of design. All the designers interviewed for **DIALOGUE** emphasized the importance of collaborations and working with people outside their own companies. Many graphic designers have a core group of specialists such as photographers, illustrators, copywriters and printers who they work with frequently, and who they can trust to come up with creative answers to a brief and deliver on a job. Collaborations can take place with such people, who are often friends and who can be relied upon to deliver, or with new faces, offering an interjection of new talent, a fresh and challenging approach that stimulates all parties involved.

CREATIVE REVIEW
Cover
Designer: Mark Errington
Client: Creative Review
2004

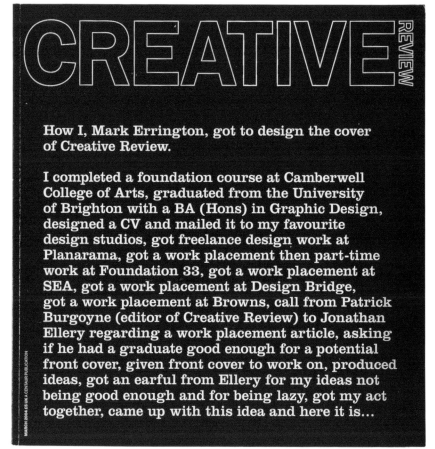

CREATIVE REVIEW

How I, Mark Errington, got to design the cover of Creative Review.

I completed a foundation course at Camberwell College of Arts, graduated from the University of Brighton with a BA (Hons) in Graphic Design, designed a CV and mailed it to my favourite design studios, got freelance design work at Planarama, got a work placement then part-time work at Foundation 33, got a work placement at SEA, got a work placement at Design Bridge, got a work placement at Browns, call from Patrick Burgoyne (editor of Creative Review) to Jonathan Ellery regarding a work placement article, asking if he had a graduate good enough for a potential front cover, given front cover to work on, produced ideas, got an earful from Ellery for my ideas not being good enough and for being lazy, got my act together, came up with this idea and here it is...

MARCH 2004 £5 UK A CENTAUR PUBLICATION

The process of design is fundamentally affected by the set-up of each design practice. This dictates how much work is undertaken, how it is shared out within a company and the impact on working relations both within and outside the company. Advertising and graphic design companies can employ dynamic ways of working that are not possible in less creative industries. The way in which studios and offices are organized acts as a form of pitch to clients. Arrangements that are deliberately anti-corporate can appeal to commercial clients, emphasizing creativity alongside a willingness to experiment and rise to challenges. Client decisions may not necessarily be made on the strength of a portfolio of work, but because of the working patterns and structure of a design studio, or a similarity in outlook and structure.

Many large design consultancies and advertising companies have creative teams and large numbers of people who fulfill other, more administrative roles. Departments with titles such as client services, business development, account management and tracking all take particular roles, freeing the 'creative' teams or designers to work on the physical task of designing. Other, usually smaller companies feel that the direct communication and personal accountability of designers assuming these roles is an important part of the whole creative and design process: that it is essential for the understanding of the project as a whole, and beneficial to the client/designer relationship and the successful completion of the project. The founders of many small companies feel that it is important to keep their companies small so that they can retain a hand in the designing and do not become business managers. Keeping a company small can also preserve a certain flexibility and informality that appeals to both the staff and potential clients.

In an increasingly competitive world it is important (particularly for large corporate consultancies) for management or principals to offer incentives to keep their staff. With a growing number of students graduating from graphic design courses each year, the competition is fierce. Williams Murray Ham partner Richard Williams acknowledges the 'responsibility' for the people his company recruits but observes that 'properly managed personal development programmes – in contrast to salary discussions – are as rare as rocking horse shit'.[20]

It is not just motivating junior staff that is important, as design journalist Linda Relph-Knight has pointed out. 'A reinvigorated creative director or senior designer can have just as much impact on a consultancy's creative performance.'[21] The support of established designers is thus important, as is the role of professional bodies, such as the Institute of Practitioners in Advertising (IPA) and British Design and Art Direction (D&AD) in running workshops and schemes that encourage ongoing professional development and closer communication between business and design.

ANN LEE: WITNESS SCREEN
Design Group: M/M (Paris)
Client: Pierre Huyghe and Philippe Parreno
2000

A key role within the industry for established designers is in teaching. Many designers teach in a formal capacity on graphic design courses, while others, such as Ali Tomlin, Creative Director at Carter Wong Tomlin, give more informal lectures at schools and colleges, where designers get not only a 'huge kick out of giving something back' but also 'a completely fresh, untainted approach as feedback'.

For design graduates the possibilities of employment are extremely varied. Some set up their own design practices or work for small independent design companies and choose to follow this independent route throughout their careers. [22] Paris-based design duo M/M (Paris) set up their own studio (which to this day remains small, employing just the two founding partners, two part-time designers and an accountant) where their creativity could be determined by their own rules rather than by company policy and practice, or the style and rulings of a senior designer or founder.

Other design graduates choose to follow careers within larger corporate areas of the industry, where the possibilities for roles are wider than just as a 'creative'. Working experience can vary according to the types of client that the agency chooses. Graphic designers work not only in the service of commerce, but also in cultural, state, social and political concerns. For many the experience of the corporate world can be very different from that of a design student. However, major agencies often try to find ways of allowing their recent graduates and junior staff to foster their individual creativity – frequently through self-initiated projects – to inject new life into the company and to ease the transition from art school to work.

London design agency Coley Porter Bell (founded in 1979) is part of the worldwide communications group WPP.[23] It employs forty-four staff, eighteen of whom are designers and eight production artists. The remainder are in administration, client handling and planning departments. The company runs a 'blue sky' scheme that encourages junior staff to work on projects of their own choosing and is intended to stimulate creativity without the boundaries of a commercial brief. It is run in the form of a competition, with a prize of £2,000 and two weeks extra holiday.

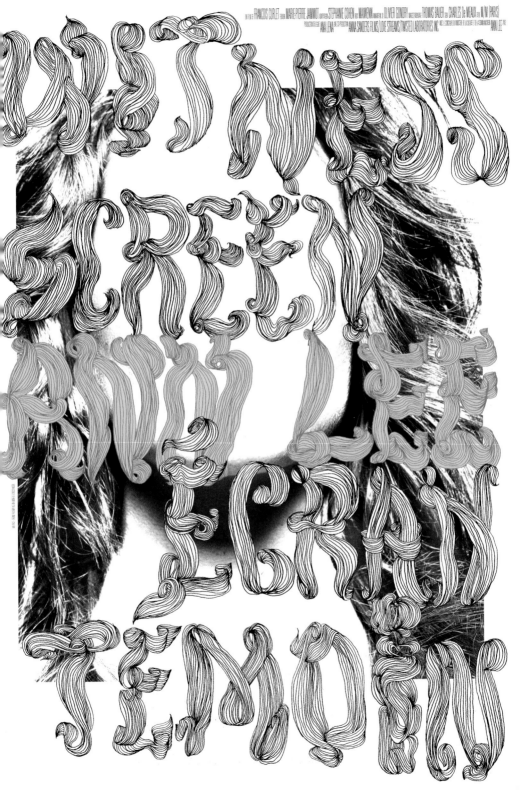

C-SYSTEM
Colour sheet
Designer: Jade Aloof
2002

Red Brick	Tomato Red	Salmon Pink	Baby Pink
Burgundy	Raspberry Crush	Bubblegum	
Burnt Orange	Carrot	Peachy Peach	
Olive	Banana	Zingy Lemon	Mellow Yellow
Khaki	Lime	Apple	Mist Green
Alpine Green	Turquoise	Bright Sea Green	Soft Aqua
Forrest Green	Emerald	Grass	Sea Green
Midnight Blue	Deep Blue Sky	Powder Blue	Baby Blue
Navy Blue	Royal Blue	Dusty Blue	Milky Blue
Red Wine	Sexy Serece	Dusky Pink	
Plum	Blackcurrant	Dusty Blackcurrant	Milky Pink
Deep Purple	Vivid Purple	Lavender	Cool Mauve
Black	Slate Grey	Elephant Grey	Cool Grey
Fawn	Beige	Cream	White
Dark Chocolate	Toffee Brown	Caramel	Biscuit

Gold

Silver

C-SYSTEM
Swatch reader
Designer: Jade Aloof
2002

In 2002, D&AD Student Award winner Jade Aloof was hired by Coley Porter Bell immediately after graduating from Norwich School of Art, where she studied graphic design. As part of Coley Porter Bell's corporate design team she was immediately put to work on a project for long-term client Kimberley Clark, rebranding and repackaging **KOTEX**, a women's sanitary product. She was also encouraged to enter the Blue Skies competition, for which she undertook a project that looked at blindness. While she didn't win, Aloof was encouraged to pursue her ideas and enter the Business Design Association Design Challenge, an annual scheme that awards innovation through inclusive design and is run in association with the Helen Hamlyn Research Centre, set up in 1999 at the Royal College of Art London to examine the design implications of social change and promote a more socially inclusive approach to designing.

In order to develop the **C-SYSTEM**, a clothing labelling system for visually impaired people, Aloof consulted a focus group drawn from the creative industries. The group consisted of people with varying degrees of visual impairment, which enabled Aloof to understand both their requirements and their perceptions of colour. As the project progressed she worked one on one with a blind girl. She said, 'I didn't put pen to paper without testing it on Becky first. So from beginning to end there was always somebody who was blind testing shapes and textures.'

To create the labels Aloof condensed the vast range of colours and shades into fifteen core colours and gave each a shape. Each core colour was divided to make four distinct sets, where pastels have a raised quarter of a shape, fresh colours half, primary colours three-quarters, and deep colours fill the whole shape. 'To signify patterning or writing on the garment the shape was ribbed,' Aloof explains. The C-System won the Design Challenge, and Aloof was allowed time to further develop the system working with a creative director and the in-house production team, who created mock-ups of the swing tags, mobile barcode scanner and silk labels to be sewn into the garments.

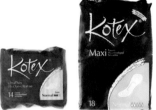

KOTEX PACKAGING
Before Coley Porter Bell redesign

Discussing her creative process, Aloof concedes that, 'I'm really not from the school of computers, partly because I find it stunting. I love the freedom of being able to scribble things and sometimes I don't even get on the computer. It pretty much goes straight from my scribbles to the production team.' Even though Aloof was allowed a certain amount of time and financial support to achieve the C-System project, as it was a charity project she did most of the work on it outside her normal working hours due to the commitments and pressures of the Kotex project.

Kotex was Coley Porter Bell's first design job in this product sector, and despite the fact that they had worked on other Kimberley Clark products they were expected to develop a fresh approach. The brief allowed, Aloof recalled, 'for a blank canvas; all they wanted to keep was their red dot, and everything else could be scrapped'. Believing that graphic design 'is becoming more like advertising, becoming a very exciting way of doing what's otherwise quite a mundane form of shopping' led Aloof to consider that the packaging for Kotex should be like 'advertising on the shelf', and her design ideas reflected this. Aloof's clean and simple scheme, designed after research into the types of image and packaging women found appealing, was chosen by Coley Porter Bell's Visual Planning team as their preferred design.

Visual Planning is Coley Porter Bell's means of formalizing the process of questioning and developing a brief from clients. It attempts to get away from purely written briefs and translate them using images to define the brand in a new and fresh way. Importantly, it involves not just agency representatives from the account team, but also the designers who are actually responsible for delivering creative solutions in the early research stages of the design process. According to Business Development Director David Lightman, it allows the team working on the project to: 'a) get under the skin of the nuances of what the brand is all about, and b) have a new vocabulary, getting rid of the same words like "classic" and "passionate" that come up time and again in briefs'. It is from this intellectual, rational and emotional understanding of the brand that a new brief for the designers can be produced.

KOTEX PACKAGING
Design Group: Coley Porter Bell
Designer: Jade Aloof
Client: Kimberley Clark
2003

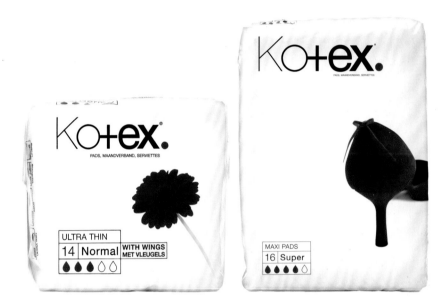

Choosing Aloof to work on the Kotex project proved successful as she brought a youthful freshness to it. She was responsible, under the guidance of creative director Stephen Bell, for designing a new logo and packaging for all Kotex products. For Kotex, Aloof was responding to a brief for an international commercial client, working under constraints of time and budget and demands of the commercial world. Although there were certain factors imposed by the Business Design Association on the brief ('Innovation Through Inclusive Design') that Aloof had to adhere to for the C-System, these related to generalizations about type of audience/end user rather than specifics of time and budget. Working on two projects simultaneously allowed for a cross-over of thinking and ideas between the two, and Aloof's pared down, clean and slick design style is reflected in both the C-System and Kotex projects.

For Aloof the relationships she built up on these two projects, both within Coley Porter Bell and with outside clients and collaborators, were new. For more established designers the fostering of long-term working relationships is a key component of a successful working practice.

DESIGNER AND CLIENT PARTNERSHIPS

IF YOU VIEW YOUR DESIGNER ONLY AS A VENDOR, THAT IS THE KIND OF OUTPUT YOU WILL GET. IF YOU CONSIDER YOUR DESIGNER A PARTNER IN YOUR BUSINESS, YOU'RE A LOT FURTHER ALONG THE ROAD TO ACHIEVING YOUR GOALS.

MARTIN SCOTT JARRET, FOUNDER OF RAY GUN PUBLISHING

**YOU CAN FIND INSPIRATION
IN EVERYTHING**
Cover
Design Group: Aboud Sodano
Designer: Jonathan Ive
Client: Violette Editions
2002

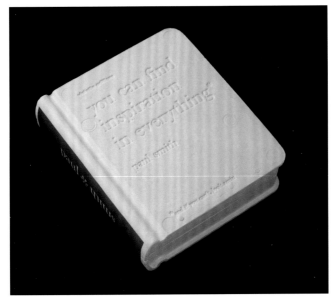

Throughout the history of design there have been a number of legendary client and designer relationships, such as IBM and Paul Rand, and Apple and Jonathan Ive. These were successful and productive because they were based on a number of key factors: mutual respect and trust, the capacity to take risks, an openness to experimentation and of course the reaping of financial rewards. It is the closeness described by Scott Jarret that has led to these and many of the other most successful partnerships. The development of an ongoing relationship with a client can result in exciting and productive results and the building of a meaningful body of work. Working as part of the client's organization imparts certain constraints and freedoms upon a designer that do not exist in a purely client/designer-based arrangement, resulting in a unique pairing.

YOU CAN FIND INSPIRATION IN EVERYTHING
Covers
Design Group: Aboud Sodano
Client: Violette Editions
2002

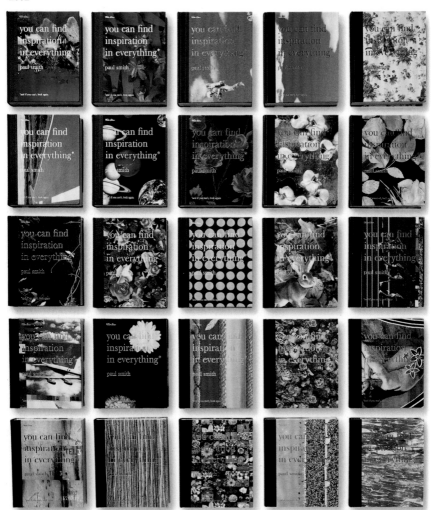

ABOUD SODANO
PAUL SMITH

One relationship within contemporary graphic design that is often viewed as an 'ideal' is that of graphic design company Aboud Sodano and fashion designer Paul Smith. It is a long-standing arrangement that began in 1989 when Smith's head buyer saw Alan Aboud's work at his degree show at Central Saint Martins School of Art in London. Aboud attributes the success of his working relationship with Smith to the progression of trust that has grown up over the years, but says that 'it's only really in the last three years that we've become very comfortable with each other; it's a long process to get to know someone so well'.

In 1989 Aboud set up a collaborative practice with fellow St Martins graduate Sandro Sodano. The key to the longevity of Aboud Sodano has been their flexible 'open' relationship, which has allowed them to undertake their own projects and collaborate with others, as well as regularly working together. Sodano works for Paul Smith both with Aboud and independently. Sodano first began working with Paul Smith in 1989, when Aboud invited him to take photographs for a Christmas brochure. Smith was impressed with Sodano's work and asked him to produce images that were printed on Smith's clothes. From that point onwards Sodano took the images that, combined with Aboud's art direction and minimalist typography, have come to be synonymous with the image of Paul Smith.

The flexible working style of Aboud Sodano has been highlighted by Aboud's creation of a new agency, Yard, in New York with Stephan Niedzweicki, former Creative Director for Gap Kids who had worked with both Aboud and Sodano on various projects. The rationale behind this move was partly client led, as American clients like to have a close physical proximity to their design agencies, but also, Aboud explains, because 'we didn't want to set up Aboud Sodano in New York as there are different partners involved and we didn't want Yard to come over to London and people to assume Aboud Sodano had folded'. The creation of Yard has allowed for a greater flexibility of working patterns, where both companies can collaborate on large projects and exchange knowledge and expertise.

In his role as Art Director for Paul Smith Ltd (a position he has held since 1990) Aboud has regular fortnightly meetings with Paul Smith to discuss work and ideas, and to plan future directions, a practice that Aboud believes encourages their close understanding.

One of the projects discussed was a book about Paul Smith. Reluctant to do a typical fashion designer book, Aboud persuaded Smith that they could work with publisher Robert Violette (with whom Aboud had worked on a book about London club scene 'face', performance artist and artists muse, Leigh Bowery). As a publisher Violette has a very open attitude towards the graphic designers working on his books: '[I] give the designers lots of freedom, give them the best brief and let them get on with it.' [25] Smith left Aboud and Violette to work on **YOU CAN FIND INSPIRATION IN EVERYTHING** (2002) without much interference, placing Aboud in the position of both the client and art director/designer. They developed their own brief for the project – to produce a book based on a Paul Smith lecture that explores the art of seeing and the inspiration that can be drawn from the world around. 'Paul doesn't go for the obvious script,' Aboud observes, 'so we adopted to that same situation for the book.' In the same way that Aboud's relationship with Smith (and with Sodano) is flexible, so the boundaries between Aboud as designer and Violette as publisher were broken down. 'I had a lot of say in the editorial content,' recalls Aboud, 'and he had a lot of say in terms of the design, but still we were both reverential enough to each other's careers to balance the other if there was a clash of ideas.'

To reflect Smith's openness to a wealth of inspiration and his inclusive working methods, Aboud and Violette proposed that 'You Can Find Inspiration in Everything' should be a collaborative product and asked Smith's friends and colleagues to contribute to the book. The briefs were very 'free', allowing the contributors to produce something that they felt made a comment about Paul Smith and his vision. The briefs also reflected the way Smith works with others, as Aboud explains: 'We tried to get the wrong people matched up with Paul, which sounds like a ridiculous ethos, but that's what Paul does professionally, it may be the wrong print on a shirt, or choosing an architect to design a fragrance bottle.' In this way, Aboud and Violette believed they would reflect Smith's creative inspiration and practice.

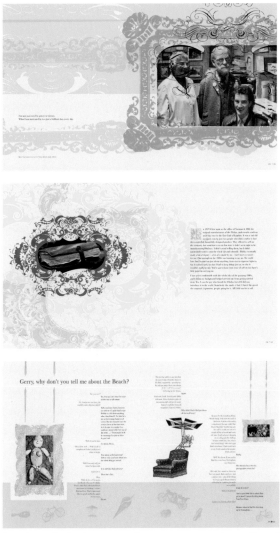

YOU CAN FIND INSPIRATION IN EVERYTHING
Spreads
Design Group: Aboud Sodano
Client: Violette Editions
2002

Contributions to the book included an introductory essay about Smith by psycho-geographer, William Gibson; 'The Bunny', a comic book within the book, with illustrations by various acclaimed artists and designers including Glen Baxter (who had a studio near Smith's shop on Floral Street) and Mick Hodgson (former Art director at 'Queen' magazine); photographs of men named Paul Smith by British photographer Paul Smith, and a polystyrene case designed by Jonathan Ive, head of design at Apple. The book was produced on a very small budget. The contributors were not paid and the cover and paper were sponsored by manufacturers. The cloth for the bindings was from the previous year's Paul Smith collections and bought at a discounted price from Paul Smith Ltd.

YOU CAN FIND INSPIRATION IN EVERYTHING
Single pages
Design Group: Aboud Sodano
Client: Violette Editions
2002

Photo: Liz Powell, Leicestershire, England, 1994.

Our collection is unconventional in both size and depth. Quantity is the key to keeping costs down and we have shorter runs than most – we might produce a run of 500 sweaters, while Marks & Spencer wouldn't make fewer than perhaps 20,000. We want to make it unlikely that you'll go into a pub or club and meet someone wearing the same thing.

We compensate by having a much wider range than other designers – maybe 1,000 rather than 600 items in a collection. That means almost three times as many paper patterns in graded sizes. Then there are the detailed specifications – colour, buttons, lining – all multiplied 1,600 times. It becomes like an arena nonetheless.

We probably suffer less from an increase in variable costs than most businesses – although we do get affected when the pound drops or cashmere prices go through the roof. Our clothes are not price-sensitive like other commodities, in the sense that sales would not drop if a suit cost £10 more.

Preparing a collection is an incredibly long and expensive process and is one of the main reasons why fashion companies go under. I can't work on a Spring collection in February of the preceding year, dreaming up the overall look of the collection, picking the colour themes and visiting mills to supply and develop the unique fabrics we need – a one-off print or stripe. We want to be leaders, not followers, so that means doing something subtly different, even with a standard yarn blue wool.

By May we have the sample metres made up into mock-ups and samples are then made for the selling shows. We have our own show-rooms in Milan, Paris, London and Tokyo and stage our own shows in Paris and London. It's at this time that the wholesale orders are placed, and once they are collated and fabric bought, production will start in June or July. The treadmill never stops. By this time I'll already be working on the next season's collection.

Photo: Johnny Stormie Kytel, BBC Club, Pall Mall, London, 1993.

The shops themselves don't set targets for achieving a fixed sales return per square foot. Where you might expect to find an extra rack squeezed into another shop, you're just as likely to find a sofa, moped or painting in one of mine. A lot of the things don't turn into money directly, but they give people a special feeling about the place, which pays off in the end.

The other thing we do is throw in a range of inexpensive items – perhaps something as daft as a toothbrush – so that we end up with very few people actually walking out without buying anything. It encourages them to come back another time when they may buy some clothes.

Financially, we're conservative. There was a time when we could have thought about going public, but we never aspired to it. We ploughed money back into the business in the form of bricks and mortar – buying our freeholds in Covent Garden and in Nottingham – which have made banks comfortable about dealing with us when we need short-term finance.

We've also found the value of treating wholesale customers well during a recession. We've never forced anybody to take a certain amount of stock, which some of our rivals do. The strange thing is, it has all worked.

Recession blights many companies in the fashion business, but we've always come through with sales rising. We've never had a grand master plan dreamed up in some ivory tower. The shops and wholesale operation just grew and grew.

We do have a very focused marketing strategy – we saved in, with retail turnover of about £313m worldwide. But we still manage to keep it fairly light-hearted.

When the orders are actually shipped, cash flow is at its weakest and this is when some houses get stretched to bursting point. All the money has gone out on bowls, flights, zips, buttons, fabrics and shipping. The actual production of clothes – cut, make and sew – is traditionally paid for in seven days. But our a penny has come in from wholesale clients around the world. You need credit controllers who can say 'pay up please' in 30 languages. We are incredibly lucky to have the retailing side. Give or take seasonal variations, it is a regular earner for us, flattening the downturns and valleys of the cash flow throughout the year. Resulting you appear to cotton as an inspired move on our part, but we did it the other way round. I started with a shop, then designed a small collection to sell in it. Only then did I become conscious of how important it was for cash-flow.

Photo: Mary Vette, New York, 1988.

For Aboud Sodano, 'You Can Find Inspiration in Everything' was a major project during 2000/2001. All six designers in the studio worked on aspects of the book while Aboud art directed the whole project. The studio is flexible in terms of numbers of staff, growing or shrinking over time to reflect the number of projects being undertaken and the general climate within the industry. It was important to Aboud that the project was a collaboration within the studio as well as outside it. He feels that this reflects his approach of 'bowing to other's talents where necessary and acting as a catalyst to their ideas and skills'. The studio consists only of 'creatives', who undertake all aspects that the job requires. Aboud stresses that it is important to the running and flexibility of the company that it does not have account or office managers and that he does not see how certain roles, such as dealing with printers, need to be separated out. The studio is kept small to enable Aboud to remain a designer and not just a company director (a role he plays, as Creative Director in two companies). However, the size of the company does not negate its ability to work with high-profile clients, as the relationship with Paul Smith illustrates.

Aboud Sodano's clients have primarily been drawn from within the image-driven world of fashion, but they have also worked with a range of other clients (including Guinness and the Terrence Higgins Trust). In many cases the work was conducted over a number of years, allowing ideas and the relationships to grow and develop. Aboud is aware of the need to set new challenges and offer new outlets for creativity, but also to 'give something back'. He balances well-paid commercial work with projects for socially aware causes, such as PETA (People for the Ethical Treatment of Animals). He also takes time to view the portfolios of young designers and students and teach when invited, something he believes he has learnt from his close working partnership with Smith: 'I have the utmost respect for him. On a business level I've learnt a lot of things from him, and on a creative level I am still learning a lot of things from him, but the overriding thing that he's given me is a sense of politeness and diligence and the obligation to put a lot back into the industry – that's the biggest thing I've learnt from Paul.'

PAUL SMITH LTD
Advertising campaign
Design Group: Aboud Sodano
Client: Paul Smith Ltd
2003

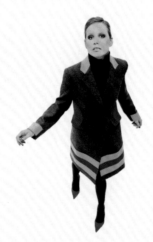

PAUL SMITH LTD
Advertising campaign
Design Group: Aboud Sodano
Client: Paul Smith Ltd
2004

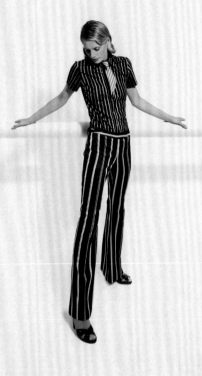

BITS + BOBS
Poster
Design Group:
Liverpool Health Promotion
Service Design Studio
Client: Liverpool Health
Promotion Service
2000

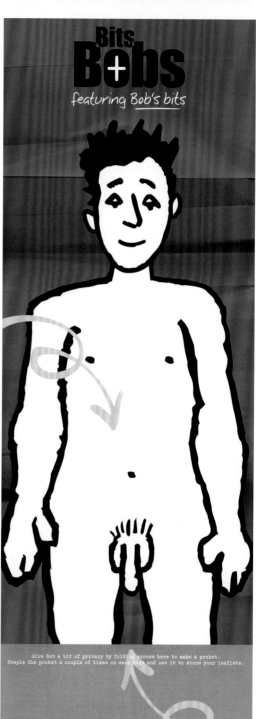

Bits
B+bs
featuring Bob's bits

Give Bob a bit of privacy by folding across here to make a pocket.
Staple the pocket a couple of times on each edge and use it to store your leaflets.

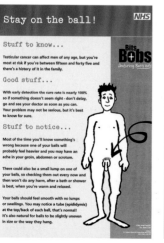

Stay on the ball!

NHS

Stuff to know...

Testicular cancer can affect men of any age, but you're
most at risk if you're between fifteen and forty five and
there's a history of it in the family.

Bits
B+bs
featuring Bob's bits

Good stuff...

With early detection the cure rate is nearly 100%
so if something doesn't seem right - don't delay,
go and see your doctor as soon as you can.
Your problem may not be serious, but it's best
to know for sure.

Stuff to notice...

Most of the time you'll know something's
wrong because one of your balls will
probably feel heavier and you may have an
ache in your groin, abdomen or scrotum.

There could also be a small lump in one of
your balls, so checking them out every now and
then won't do any harm, after a bath or shower
is best, when you're warm and relaxed.

Your balls should feel smooth with no lumps
or swellings. You may notice a tube (epididymis)
at the top/back of each ball, that's normal!
It's also natural for balls to be slightly uneven
in size or the way they hang.

LIVERPOOL HEALTH PROMOTION SERVICE
BITS+BOBS

Liverpool Health Promotion Service (LHPS), a department of Central Liverpool Primary Care NHS Trust (CLPCT), has had an in-house graphic design service for about fifteen years. Around 10 per cent of the studio's work is carried out for LHPS, while the majority of their design and communication activity is for the CLPCT and its neighbouring North and South Liverpool Trusts. As many campaigns are city wide they are produced for all three Liverpool trusts. As an 'in-house' design service, Andrew Dineley and his two fellow designers are responsible for designing resources for the National Health Service – reports, policies and general promotional ephemera – as well as 'campaign' work. LHPS's work is, he explains 'more geared towards the educational side, working on the prevention of illnesses like heart disease and AIDS; dealing with stuff before it happens'.

Working within the NHS the team are bound by very specific design guidelines introduced by the NHS, as well as having to ensure that all the material they produce addresses the best practice guidance laid out in the Disability Discrimination Act. Initially, Dineley saw the introduction of NHS design guidelines as a constraint on his team's work, as previously they had had free reign. He now, however, views these guidelines as rather liberating: 'Having specific fonts and colours allows us to focus on effective concepts and messages without having to ponder the subjective minutiae of clients' favourite colours or fonts.'

Working within the NHS also puts financial constraints onto design projects as it can be, Dineley observes, 'counter-productive to produce materials that look too glossy or expensive when ultimately NHS funding should be going into patient care'. However, Dineley and his fellow facilitator in the Designers in Health Network (a mutual support group for designers working in the NHS), Brian Parkinson, believe that design is a key factor in spreading messages and making information accessible to patients and health care workers. The issue, Parkinson says, is 'what's the most effective and cost-effective way of raising the overall standard of visual communication?'[26]

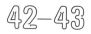

In 2000, aware of a lack of material that discussed men's health in a 'simple, direct and sport-free way', Dineley devised appealing and non-threatening testicular cancer materials that were clear, concise and cost-effective. Dineley's initial research indicated that much of the material already in existence used what he perceived as an outdated pun on balls of a sporting and testicular nature. He felt that in order to reach a broader audience, the material needed to combine clear, simple information with bold, intriguing and slightly tongue in cheek graphics. The **BITS** + **BOBS** campaign drew its name from a euphemistic day-to-day term that reflected the humanistic language and terminology included in the materials. This approach received positive feedback from the men's health support group that Dineley worked with during the concept stage. Dineley himself wrote the copy as well as designing the materials, placing himself in the role of 'author', but ensured that all materials were checked by health professionals to ensure factual accuracy.

The cartoon character 'Bob' was rendered with an Adobe Illustrator package, to achieve Dineley's aim of using a simple graphic style that was consistent with the basic copy. Simple, clear fonts reminiscent of a traditional typewriter were used, along with hand-painted arrows and asterisks to increase the accessibility of the information. As a subtle reference to the nudity in the resources, creased brown paper bags often associated with 'top shelf' pornographic publications were scanned to create backgrounds. The materials produced ranged from conventional leaflets and posters to more quirky T-shirts, badges and 'hairy' balloons designed to be hung 'in pairs for maximum effect!' In order to get around a perceived embarrassment among the target audience being seen reading the material in public, the poster was designed as a storage device for the leaflets with text removed in favour of an arrow encouraging the user to reach into the pocket to 'get hold of Bob's Bits!' Equally important to the design was addressing health care professionals who would pass on the material and information to their patients.

The campaign, which was an LHPS initiative rather than for the wider NHS Trust, was produced on the LHPS very small print budget. Selling the materials outside Liverpool to other NHS Trusts, alongside free distribution within Liverpool, generated an income that has been ploughed back into future print runs. The success of the Bits + Bobs campaign (four print runs in three month) led to the expansion of the campaign to cover other men's health issues such as prostate cancer, mental health and coronary heart disease.

BITS + BOBS
Materials
Design Group: Liverpool Health
Promotion Service Design Studio
Client: Liverpool Health
Promotion Service
2000

Working primarily within the NHS, Dineley notes that the majority of his clients are non-creative people and so 'communicating effective design principles' is always the first step in a design project. He never receives written briefs from his clients – 'the concept is alien to them'. It is essential to Dineley to work closely with the client to interpret any specific ideas they have in mind and to achieve this within a set of defined criteria – budget, target group, deadline and format. Similarly, his experience has proved that his clients have difficulty in conceptualizing ideas, so the rough drafts for a concept have to look 'real' for them to understand how the materials will work. The production of PDF proofs and presentation of mock-ups of material, such as T-shirts or Bus Stop ads and Mug designs, are key stages in the design process.

BBH LONDON
LEVI'S JEANS

Levi's jeans company has had a long and successful relationship with advertising agency BBH London, founded in 1982. BBH London have one Creative Director, Stephen Butler, who is solely responsible for the Levi's account, overseeing and presenting the work carried out by the creative team to the client. The initial brief is created jointly by the client and BBH London's Creative Director, account team and planners. The account team then decide which of the twenty creative teams will receive that particular brief. In the case of **LEVI'S TYPE 1 JEANS**, launched in 2003, responsibility for creating a print campaign – posters and press advertising – was given to Dean Wei and Joseph Ernst. The traditional creative team within advertising consists of a copywriter and an art director working together. Whilst Wei and Ernst have a preponderance towards copy-writing and art directing respectively, they each contribute to both disciplines in a collaborative manner. This was, they believe, a key component of the successful completion of this project.

Type 1 jeans are characterized by an exaggeration of the main features: rivets, buttons, stitching and label. One of the specifications of the Type 1 brief was that the campaign kept the 'bold new breed' strapline of the existing television advertising. 'The brief is always the starting point,' Dean Wei observed. 'Every client will say the brief should be the answer, but for us the brief is and should be part of the creative process.'

Wei and Ernst's solution was to focus on the exaggerated details by removing the hands and heads of the models and creating an image of an anonymous wearer in whom consumers could envisage themselves. They wanted the work to be photographic but to have a strong graphic quality. In order to convince Levi's that their simple approach would work, Wei and Ernst presented a rough A4 size version of the proposal to the client from across a room, proving that an image with just the barest of details would work in a variety of formats, from magazine adverts to building wraparounds.

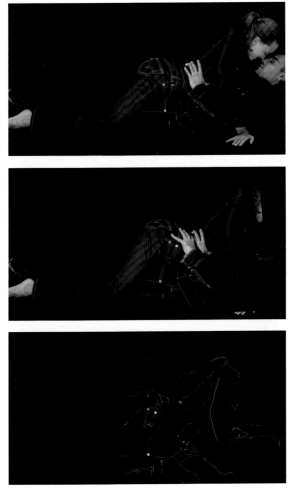

LEVI'S TYPE 1 JEANS
Initial photo and
computer manipulation
Agency: BBH London
Art directors/copywriters:
Dean Wei and Joseph Ernst
Client: Levi Strauss
2003

Levi's accepted the solution and Wei and Ernst appointed photographers Warren du Preez and Nick Thornton to create the basic images. Wei and Ernst had not previously worked with du Preez and Thornton, but had viewed their work and believed they would understand the requirements of the brief. Viewing new photographers' and illustrators' work is a key function at a large advertising agency like BBH London, who have many clients to service and projects to undertake, each requiring something individual and unique. Wei believes that for BBH 'not working with the same people all the time is a function of the fact that you are not going to have three jobs in a row which have the same requirements'.

46—47

LEVI'S TYPE 1 JEANS
Computer manipulation
Agency: BBH London
Art directors/copywriters:
Dean Wei and Joseph Ernst
Client: Levi Strauss
2003

THE STITCHING SEEMS TO FADE AWAY IN PLACES ...
IN SOME INSTANCES THERE ARE SHADOWS ...
OR CHANGES IN THE BRIGHTNESS OF THE STITCHES ...
ALL THE STITCHES SHOULD BE EQUALLY BOLD ...

IF THEY HAPPEN TO FALL AT AN ANGLE, THEN THEY MIGHT BE LESS THICK,
BUT THERE SHOULD BE NO LIGHTING/TONAL VARIATIONS IN THE STITCHES ...

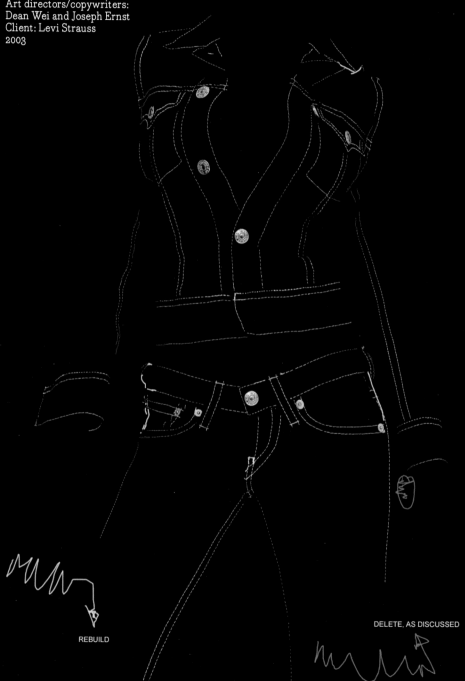

REBUILD

DELETE, AS DISCUSSED

LEVI'S TYPE 1 JEANS
Initial photo
Agency: BBH London
Art directors/copywriters:
Dean Wei and Joseph Ernst
Client: Levi Strauss
2003

Achieving the desired 'illustrated' look through photography required a close flexible working relationship between Wei and Ernst and the photographers, as well as with a technical production team at BBH. Wei and Ernst took an initial photograph, which was used to create an initial 'scamp' (or rough layout). Using Adobe Photoshop, a colour filter was placed over the image to fade out the background and highlight the details. Initially, the photographers used their assistant to take test shots to find whether the initial poses suggested by Wei and Ernst would work. Achieving the range of twenty-five poses required the creation of a structure with holes and poles to allow the models to 'drape' themselves and comfortably hold poses while they were photographed.

Once the Photoshop filter was applied to du Preez and Thornton's photographs, it was possible to choose the eight images with the clearest forms to be used in the final campaign. Wei and Ernst then spent weeks working on a computer, colour matching individual stitches and manipulating the images (often using elements from the rejected photographs) to allow the unique details of the Type 1 jeans 'to be clearly seen against the dark blue of the "denim" background'. Once the type sizes had been agreed, Wei and Ernst worked closely with BBH London's internal design studio to choose a typeface and set the final layouts. Ernst recalls that for each format 'a new layout was required to allow for the image to sit correctly within the format and balance the details and text against the negative space'.

'Different clients will give you different constraints,' Wei observes. 'Some clients have specific codes which are inbred within their cultures. So you need to very quickly learn what room you have to manoeuvre and find the best way of leaping out of that.' The presentation of the red tag logo and strapline for the Type 1 campaign was an example of where Wei and Ernst eventually had to compromise. They proposed using a photograph of an actual cloth Levi's tag at the top right of the image, reflecting the highlighted details of the jeans. As the Levi's logo is a key element in encouraging brand loyalty among customers, Levi's were insistent that it retain a consistency with all their other print work.

LEVI'S TYPE 1 JEANS
Posters at Oxford Circus Station
Agency: BBH London
Art directors/copywriters:
Dean Wei and Joseph Ernst
Client: Levi Strauss
2003

Printing limitations, combined with budget constraints, also had an impact on the end product. Problems arose because of the different types of paper and printing technique used to produce the various versions of the advertisements, from magazines to huge building wraparound hoardings. In order to print at the larger sizes the depth of colour had to be compromised and a balance struck between the level of the uniformity of the main colour and the quality of the line in the stitching details. For lightbox poster holders at bus stops, Wei and Ernst had to investigate printing techniques and materials that would produce the specified depth of colour and allow the image to be seen clearly both when lit up at night and unlit during the day. The design and production process is always, for Wei, an opportunity for learning: 'Because the idea will be new and different there will be a new challenge technically. So with every job you need to learn something new.'

M/M (PARIS)
BJORK
AND MADONNA

According to Matthias Augustyniak of French design group M/M (Paris), 'There are two ways of working with clients. There are people who take the time to work with us and really inspire some kind of conversation or deep relationship and there are people who hire us just because we are skilfull.' These two ways of working are illustrated by comparing their work for, and working relationship with, musicians Björk and Madonna.

M/M (Paris) was founded by Matthias Augustyniak and Michael Amzalag in 1992 after they met at Ecole Arts Decoratifs, Paris. They entered graphic design because they felt it was at the cross-section of many different media networks and allowed them a framework in which to express their ideas and points of view on life. They continue to view graphic design as one of the fundamental cornerstones of a company or institution's relations with the world around them, and to believe that as graphic designers they are able to offer solutions to the problems a client may face in their relationship or communication with the wider world.

For M/M (Paris) the most interesting part of their creative process is the time they spend talking to people, thinking and nourishing the work. They are interested in developing long-term, lasting relationships with their clients that are, Augustyniak notes, like 'ongoing conversations, twisting and turning but always a continuum'. They prefer their clients to approach the partnership as if it may be a lasting one – the first piece of design is the first step on a journey, even if there is no formal contract for this. It is, says Amzalag, like, 'a concert; you need a time of adaptation, where you try to get a proper sound, where you finetune everything'.

BJÖRK: VESPERTINE
Record sleeve
Art direction and illustration by M/M (Paris)
Photographed by
Inez van Lamsweerde & Vinoodh Matadin

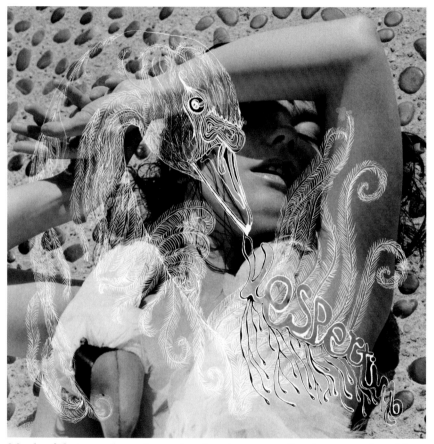

Much of their work explores the development of an image and an idea, where each image is 'the sum of preceding dialogues, stories and experiences' – not a single piece of work but part of a series that sits between the previous and subsequent piece of work. In answer to the criticisms that their work all 'looks the same', Augustyniak argues that 'it takes time to create a real language and then after constructing a language it is also good to have the time to explore and to use it'. As a design practice they work with many clients and admit that as it is not always easy to come up with something new they recycle elements of their design. 'We think that an image can be viable more than one time,' says Augustyniak, 'it depends how you shape it and turn it.'

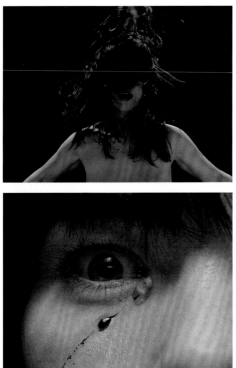

BJÖRK: HIDDEN PLACE
Video directed by M/M (Paris)
and Inez van Lamsweerde &
Vinoodh Matadin
© 2001 Wellheart Ltd/
One Little Indian Records

Icelandic singer Björk contacted M/M (Paris) after seeing the catalogues they had produced with photographers Inez van Lamswerde and Vinoodh Matadin for fashion designer Yohji Yamamoto. This long-term collaborative working relationship began when all four were hired to work on an advertising campaign for fashion designer Thierry Mugler. Subsequently, they all worked together on a series of striking and memorable pieces of work, including two advertising campaigns for fashion house Balenciaga (2001 and 2002), and two alphabets created from photographs of models whose names are associated with particular letters of the **ALPHABET** (2001 and 2003).

Impressed by the work she saw, Björk asked the duo about the possibility of working on a cover and music video for the single **HIDDEN PLACE** (2001). The resulting video, made in collaboration with van Lamswerde and Matadin, combined real-life action with computer-generated animated 'drawing' in a style that is a progression from the images created for Yamamoto. The success of the video led to the designing of the cover for Björk's album **VESPERTINE** (2001), in which a seemingly hand-crafted drawing (which is actually digitally produced) of a swan is 'scribbled' over a photograph of the singer. This image reflected the changing persona of Björk from a sweet and innocent Icelandic girl into a much more complex character, and made reference to her controversial appearance at the 2000 Academy Awards ceremony wearing a swan dress by Marjan Pejoski.

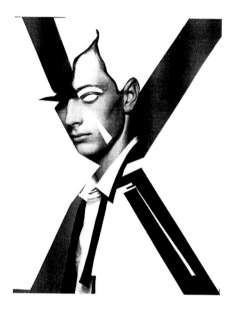

THE ALPHABET / ALPHAMEN

BORIS X
YAK
ZEV
ALEXIS
Based on original photographs
by Inez van Lamsweerde & Vinoodh Matadin
Colour silkscreened posters

Design Group: M/M (Paris)
2001 and 2003
Courtesy www.mmparis.com
and gallery Air de Paris, Paris

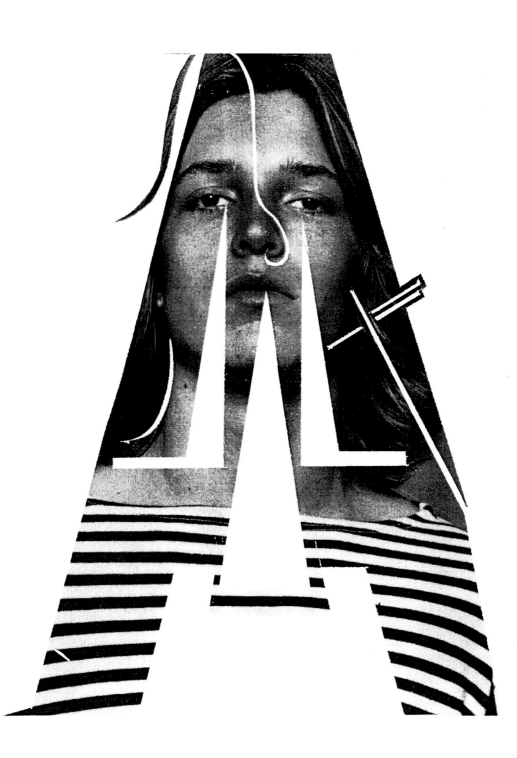

BJÖRK: WARDROBE
Cover
Design Group: M/M (Paris)
Client: One Little Indian
2001

Wardrobe

From Reykjavik, the e mail travels across the Atlantic. A girl writes to a boy: "I will come to see you and cook a dish that belongs to me." Two months later the glittering girl slides down the motorway. A message shines in the sky for her. In red dot matrice letters it reads *traffic fluide*. The sun is rising, the girl dressed up in a thousand lights crashes in a hotel room. A piece of dried lamb is supposed to arrive by the Milky Way from Iceland. In *déshabillé de jour*, she waits all of the afternoon. Six o'clock and still no meat. Adorned with a yellow-suit, the girl calls a cab. The taxi driver comes from afar and speaks seven different dialects. The girl, rearranging a purple skirt made from one single panel tells him: "I'm waiting for ten people tonight and I have no food." He replies: "Emergency situation. I'm your man." The car shoots off. The driver takes her to a huge grocery store. There, she buys dried fish, caviar, saffron, hot red pepper, cinnamon, fresh ravioli, mushrooms and milk. Her top has no back. She rearranges it in a peculiar way, then she needs cream. But the girl doesn't understand any of the words written on the packaging labels. So she takes every one of the containers likely to hold cream, opens it, digs her finger into it, sucks her finger, then puts it in the caddie. She collects six of them before obtaining the right taste in her mouth. She grabs a few blinis, goes by the cashier and back into the cab. The polyglottous man is still there. He takes her to the boy's address. When they reach the place, the girl leaves her skin on the back seat. Armed now with a pink dress inlaid with metal strips, the woman she has become, climbs up four flights without loosing her breath. Once there, she slips into the kitchen, sautés the mushrooms in butter, then, she improvises a sauce... She throws in a few things: apple juice, rhododendron honey and mayonnaise. She prepares the fish, cooks the pasta, leaves the sauce to simmer, runs her tongue along her upper lip, squints, lets her soul cry out, laughs with the boy. Björk wears her name at last

M/M (Paris) never received formal written briefs from Björk, but developed their ideas and responses to her needs through close contact, discussion and the development of a 'friendship'. Through designing a book for Björk (2001), M/M (Paris) were able to recontextualize both the character and images of Björk. Like Alan Aboud with the Paul Smith book, M/M (Paris) brought in a series of collaborators to add a variety of views on aspects of Björk's life and career. It included contributions from photographer Nick Knight, film maker Lars Von Trier and fashion designer Hussein Chalayan, alongside essays by critic Rick Poyner and artist Philippe Parreno.

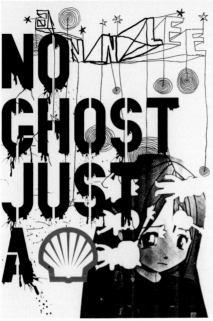

ANN LEE: NO GHOST JUST A SHELL
Poster for a project by
Pierre Huyghe and Philippe Parreno
3 colours silkscreened poster
Designed at M/M (Paris)
2000
Courtesy www.mmparis.com
and gallery Air de Paris, Paris

What M/M (Paris) have created with and for Björk is a tool kit of ideas and images, including a typeface (The Ten Commandments designed in 2000) and a black, duck-shaped 'logo', which could be drawn on to create a new piece of work but was always recognizable as Björk. Working with Björk, Amzalag said, 'was very much a progression' and he compared the relationship to that of an architect and his client, where the client 'trusts him because he has a knowledge you don't have. Trusting the skill of someone else is really important.'

In contrast, for their project for Madonna on the **AMERICAN LIFE** (2003) album cover, M/M (Paris) felt they were 'hired more like an illustrator, like an advertising company'. The brief was tight, with clear indications of what the client required from the final product. M/M (Paris) were not allowed to hear the music and were required to sign a contract of confidentiality. Many of the elements and ideas that were incorporated in the cover design were already set when photographer Craig McDean, with whom M/M (Paris) had worked on a number of projects, including a catalogue for fashion designer Yohji Yamamoto, approached M/M (Paris) on Madonna's behalf. The photographic shoot had been planned, with Madonna wearing a uniform and gun. In order to come up with their design concept they looked back at all the previous Madonna album covers and tried to reinvent the image of the album to reflect the way in which Madonna reinvents her own media persona. They referenced the instantly recognizable image of Che Guevara and describe the end result as being 'like us on the media cliché that is Madonna'.

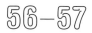

MADONNA: AMERICAN LIFE
Record sleeve
Art direction, design and illustration by M/M (Paris)
Photographed by Craig McDean
© 2003 Warner Bros Records Inc.

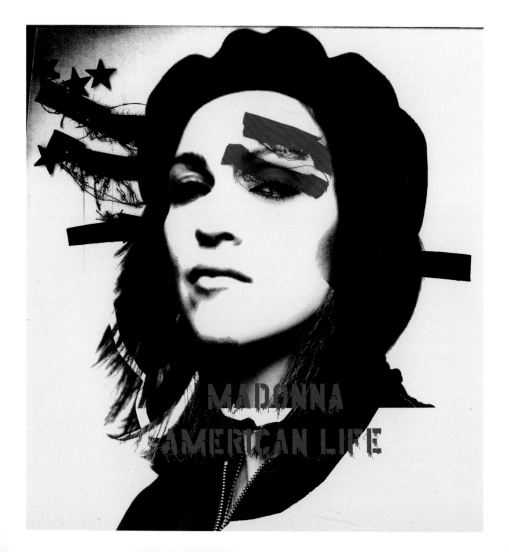

In the same way that Madonna notoriously appropriates existing imagery for her ever-evolving persona, so M/M (Paris) incorporated elements of their previous work into 'American Life'. At Madonna's request they reinterpreted the model alphabet they had previously created with van Lanswerde and Matadin, using images from the Craig McDean photo shoot. The typeface, which drew on street graffiti stencils and explored the notions of hazard (as investigated in the work of American artist Christopher Wool), had been designed for a poster for a series of art films, **ANN LEE: NO GHOST JUST A SHELL** (2000) in collaboration with artists Pierre Huyghe and Philippe Parreno. It was created on the computer with the drips consciously fabricated to give an illusion of chance. The images they created for 'American Life' have been copied and reinterpreted by an anonymous graphic designer for the cover of an illegal bootleg of remixes of the album. This led Augustyniak to reflect that 'The process of the life of this image is interesting. The process of making it is less interesting.'

Reflecting on the difference between the working relationships with Björk and Madonna, M/M (Paris) make a comparison with the fashion world (a world for which they produce much of their graphic design). 'For Madonna it is like a luxurious prêt-a-porter. For Björk we are tailoring; it is bespoke.'

THE COLLABORATIVE PROCESS

CLOSE COMMUNI-
CATION BETWEEN
PROFESSIONS
INTRODUCES AN
UNDERSTANDING
THAT REMOVES
THE INHIBITIONS
THAT INVARIABLY
HINDER THE
FLOW OF IDEAS.

ANNE ODLING-SMEE

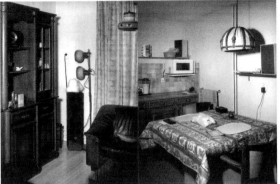

'RE-' MAGAZINE
Spread
Designer: Jop van Bennekom
2003

Graphic design is an industry that encourages collaborative work. Whether this involves working closely with a client or specialists from other departments of large companies, or utilizing the expertise of those outside the field, it is collaboration that so often ensures the successful fruition of a project. While many designers have had a broad training (either at college or on the job) and, because of the advantages of modern technology, are often adept at photography, typography, image creation and manipulation, as well as the successful combination of these elements that graphic design requires, some projects require the skills of others.

Strategic planner Larry Keeley identified the need for designers to 'combine their talents with unfamiliar expertise from other fields'. [28] He highlighted the importance of working with social scientists and strategists, engineers and materials scientists who have the kinds of experiences and knowledge not often held by designers themselves. It is not just in the areas identified by Keeley that designers need to collaborate. There are many associated fields – photography, copywriting or specifics of technology, such as printing or computer programming – where a designer can successfully cooperate on a project. The technical requirements of a graphic design project can lie outside the designer's office, often with those who are required to produce the end product, such as printers. London-based designer Morag Myerscough notes that while there have been interesting and exciting technological shifts, such as electronic printing, what is required is for printers to 'push the boat out to be a bit more responsive and adventurous. That's hard to imagine, because printing's so formulaic and the machines aren't really able to respond to unusual needs.' [29]

The following case studies illustrate the importance of collaborating with experts who have skills that compliment those of the studios and designers, in order to bring to fruition successful pieces of graphic design.

THE CHASE
'GROW UP!'
EXHIBITION

From the very first thoughts about pitching for the job of designing the graphics for the exhibition **GROW UP!: ADVICE AND THE TEENAGE GIRL, 1880s TO DATE** (2003), at the Women's Library in London, the process was one of collaboration. The pitch was put together by London design practice The Chase (set up in 2001) and Mike Cameron, a freelance exhibition designer with whom The Chase in Manchester (parent body of the London agency) had worked on previous exhibitions.[30] Together they presented a rounded design proposal, which indicated how the graphics would fit within the exhibition set. For Harriet Devoy, The Chase's Creative Director, the key to the success of a working relationship is finding someone who shares the company values or with whom there is a similar outlook. 'I've worked with a few people that I wouldn't work with again because there was no spark. It might not be that the work they are producing isn't good – it's just that there is no spark between us.'

The brief offered to the four design companies pitching for the job included a breakdown of the key themes in the exhibition, a list of key objects and information on the target audience. The designers were asked for a visual identity that worked within the exhibition hall, as well as on the programme format, invitation, poster and press advertising. The joint pitch and close working relationship between The Chase and Cameron was one of the key factors involved in awarding the job. 'It was the strongest teenage pitch,' recalled Katie Slovak, marketing manager at the Women's Library, 'and, together with Michael Cameron, the team that best used the exhibition space and captured the idea of fun.' At the pitch presentation, The Chase presented a number of possible approaches to the graphics: a photographic teeth-brace route, an almost war-like poster, speech bubbles and teenage magazine photo-strip stories.

GROW UP!: ADVICE AND THE TEENAGE GIRL,
1880s TO DATE
Pitch Idea
Design Group: The Chase
Client: The Women's Library
2003

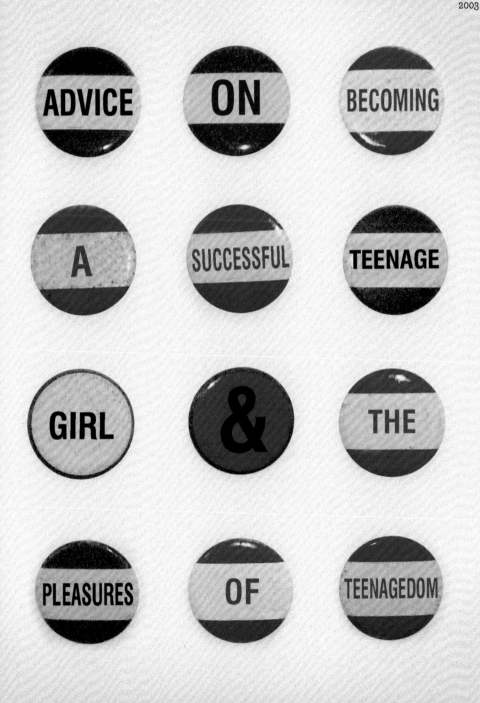

Once awarded the job, The Chase reviewed what they had presented and returned to an idea they conceived immediately after reading the brief that relied purely on the words within the pieces of advice included in the exhibition. This, they proposed, should be presented as if it had been drawn by a teenage girl, reflecting the doodles that appear on the covers and margins of school exercise books. The exhibition had to embrace over a century of teenage advice and be representative of that time span, and one of the problems with the other approaches, The Chase felt, was that it put a time frame on the teenagers. Slovak was impressed with The Chase's approach, believing that 'It was much more professional of them to win the pitch, and then not just say "well you've got a solution", but to request more information about the exhibition and present more design ideas to us.'

Due to time constraints, The Chase had to design and produce the marketing materials before they could start on the exhibition itself. In order to produce the poster, Marc Atkinson, The Chase's designer, studied a range of material from the exhibition, pulling out quotes on advice. Overwhelmed by the wealth of material he suggested producing three posters, which would allow the use of advice from across the span of the exhibition.

Once the Women's Library had agreed, Atkinson attempted to handwrite the quotes using appropriate period fonts. However, when they were drawn up they were either illegible or lost their period reference. Atkinson's solution, to combine a selection of different typefaces, was a time-consuming process that involved hand drawing, scanning, plotting on the computer, printing and redrawing in order to achieve the perfect balance of weights and fonts.

In order to ensure that the quotes worked, The Chase collaborated with a copywriter, Tony Veasey. The copywriter is an important contributor to many of The Chase's projects, ensuring that the text incorporated into their designs is clear and appropriate. Understanding and utilizing the skills of a copywriter is common practice within advertising, but less common within graphic design. Describing the ongoing relationship The Chase has with Veasey, Devoy emphasizes the need for honesty between parties: 'A lot of it is that I can be honest with Tony and say "it's not right yet, keep going." That is so important, whether it is with a photographer or an illustrator or copywriter. If everyone is being upfront it is so much easier.'

The budget for the production of the graphics for both marketing and within the exhibition was £5,000 (with The Chase's fees at around £6,000). When Atkinson suggested that he produce three posters rather than the one budgeted for he had to convince Slovak that this could be achieved within the budget. The original poster was intended to be produced in four colours, but Atkinson proposed that by using three colours the price could be kept the same. This solution used six printing plates rather than four: one for the beige body colour, one each for the pink and blue of the logo and three for the quotes.

GROW UP!
Poster
Design Group: The Chase
Client: The Women's Library
2003

6 FEBRUARY–26 APRI
MON–WED&FRI 9.30–5.30P
THURS 9.30–8.00P
SAT 10.00–4.00P
ADMISSION FRE

THE WOMEN'S LIBRAR
LONDON METROPOLITAN UNIVERSIT
OLD CASTLE STREET E17N
ALDGATE EAST

leave kissing until the end of the evening and anything else until you're married

GROW UP
ADVICE AND THE TEENAGE GIR
1880s TO DAT
AN EXHIBITIO

THE WOMEN'S LIBRAR
celebrating and recording women's liv

TEENAGE CONSUMPTION

'People use material goods to express who they are and would like to be, to construct a sense of being unique and different from others, and to acquire new identities.'
Dr. Helga Dittmar, *Getting a Life*, 2003

Consumer products featured here demonstrate the material culture of girldom which has developed since the late nineteenth century, and which is evident throughout the exhibition. Teenage girls have always been credited with possessing a sophisticated understanding of the cultural meaning of consumer goods. Shopping is not just about personal taste: it is also a leisure and lifestyle activity.

The benefits of consumption have always been controversial. On the one hand consumption has been defined as consumer entrapment. Conversely, it is frequently experienced as providing a sense of freedom and identity. For example, the mobile phone connects teenage girls with their friends and achieves a level of individuality for the owner through customised fascias. In a supposedly 'classless' society, such personalisation helps individuals create their own class of peers and define their place within it.

MAKING UP IS HARD TO DO

During the 1970s no respectable teenage girl would leave home without her lips dripping with shiny lip gloss. It was the finishing touch to a girl's re-creation of her self. This experimentation with beauty and fashion is one of the joys of being a teenager, implying freedom to play with different looks.

The twentieth century has seen a plethora of beauty products laid out in fashion and beauty spreads, as well as a dedicated literature that invites girls to aim for the body beautiful. However, critics have condemned such goals for corroding girls' self-esteem and cited them as contributing to the current growth of suicides amongst adolescent girls. The tension between the desire always to be more beautiful, with all its psychological effects, and the magic of beauty and fashion tools, which allow young girls the space to express their new identity, has been a constant theme for decades.

The small budget prevented The Chase from approaching an illustrator to create images for use in the exhibition hall and the exhibition guide. Instead they approached PYMCA photographic agency (who specialize in images of youth subcultures) and negotiated the use of three photographs from one photographer for half of the usual fee and an acknowledgment in the exhibition. These images sat alongside copyright-free images from a 1970s book and images drawn by Atkinson to reflect teenage girls' schoolbook doodling. With hindsight, Devoy feels that this led to a much more creative and successful result than they would have got had they used a professional illustrator.

As well as working with Veasey, Atkinson and Devoy worked closely with Katie Slovak at the Women's Library and Carol Tulloch, the exhibition curator, to ensure that they were happy that the texts represented the exhibition content and were accurate and attributable. Much of Atkinson and Slovak's communication utilized computer technology in the form of email and PDF files. PDF has become the standard for transferring and sharing design files and allows for the work to flow more freely. However, as Atkinson observes, PDF files can create false expectations on the client's part. 'Clients just want to see a PDF and that's it. They want to see it as fast as possible. In the end you have to scan everything and get it in on the computer for them to view.'

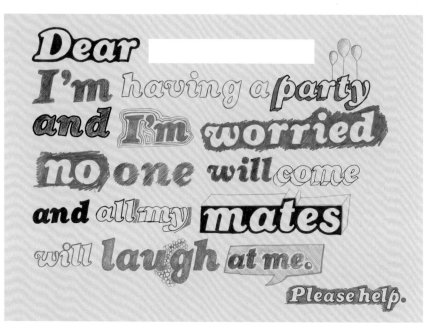

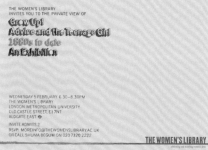

GROW UP!
Private view invitation
Design Group: The Chase
Client: The Women's Library
2003

Both Atkinson and Slovak believe that by working closely together throughout the design and production process of the material, the end product was much more successful than it would have been if The Chase had worked alone and presented finished ideas. 'They are very good at creative back and forth,' Slovak says, 'and at being persuasive and wanting their ideas to be taken up, but being able to stop that if we tell them to.' This is illustrated by the Women's Library logo, which Atkinson wanted to hand draw in black and white (to save money on printing) and to make proportionally very small compared with the main text of the poster. Slovak, however, felt that as the Women's Library was a relatively new institution, it was important for the logo to retain its pink and blue colour scheme and keep a sizeable presence on the material. The eventual compromise was that the line at the bottom of the logo was hand drawn.

For Devoy, a close working relationship between the designer and the client is key to the success of The Chase. 'I can't imagine being in a situation where we have account managers briefing us, because it's always somebody else's vision and it gets lost in the translation. It becomes a series of Chinese whispers. With all our clients [the designers] always have direct contact with them.' She also observes that a similar constraint can be imposed by the way in which client organizations are structured, particularly in large organizations or the public sector, where the person directly responsible for liaison with the designer may not be the person ultimately responsible for decision making. 'Politics can get in the way sometimes, especially with some of the bigger clients,' observed Devoy. 'You have to be sure you show things to the right people in the right order, or understand that the people that you are presenting to would then go off and present to another thirty people before you get a yes.'

FRUIT AND VEGETABLE STAMPS
Design Group: Johnson Banks
Client: Royal Mail
2003

JOHNSON BANKS
ROYAL MAIL
AND DESIGN COUNCIL

For London-based design practice Johnson Banks (founded 1992) working with a range of specialists is key to their working practice, allowing the studio to remain small, with a total of five designers, one account director and a dog! 'Collaboration is now our modus operandi, partnering whoever is best at what they do,' said founder and principle Michael Johnson, listing digital group De-construct, exhibition specialists Casson Mann, architects Wilkinson Eyre and advertising agency Hooper Galton as some of the companies they have worked with. 'I think the idea of the one-stop design company is pretty outdated now. I think that more and more clients are cool about the fact that one collaborates; in fact, I think they quite like it.'

Close working between all staff is key in the Johnson Banks office. Frequently, when a brief is received the whole company will be set the challenge of working on a solution. 'We will all work on it and ideas come up,' says Johnson. 'It's first past the post, best idea will win the job and then they get to work on it.' For Johnson Banks the computer is just one tool among many, and Johnson encourages his staff to use it for the creation rather than the conception of ideas. Personally, he uses sketchbooks to develop ideas, 'drawing a lot in sketchbooks on the way to meetings and then having a free day to stick an idea together'.

Johnson Banks regularly collaborate with a number of photographers whose work they know and who they trust to produce what is required for a job. For a project designing stamps for **ROYAL MAIL** in 2003, Johnson Banks used photographer Kevin Summers, with whom they had previously worked on a number of projects. The brief was to produce stamps that included an element of interactivity, which would encourage children to write letters. The successful solution was based on the book 'Vegetable Faces' and the children's toy Mr Potato Head (where features – eyes, noses and mouths – are stuck into a potato to create a character). It consisted of a series of stamps with photographs of fruit and vegetables and a set of stickers with which to customize the stamps. Johnson wanted to work with this particular photographer because 'there is a degree of skill in making food look appealing, without making models' and 'Kevin is really very good at making a potato look great!'

Johnson recalls that while Royal Mail liked the initial idea, 'The challenges for them were quite considerable, first because you're being asked to deface the stamp and secondly [because] there are all sorts of technical considerations where if you covered a stamp with stickers then it might not post, because there's all sorts of essential information embedded on the stamp.'

Stamp design is perhaps the most obvious example of strict limitation of scale and format that can be imposed on a designer. 'Size,' wrote Stephen Heller, 'is everything, and mastering it is crucial. Visual ideas that may be effective on a book jacket or poster will not be effective when reduced down to Lilliputian proportions.' He also observed that within these constraints and as part of the development of stamp design as a genre 'there has to be room for taking risks'.[31]

Until this set of stamps, Royal Mail had always insisted that the design remain within the edges of the stamp (even if the shape could vary), but in this instance they encouraged Johnson Banks to be innovative and allow the image to 'butt out of the square'. The shapes of the fruit and vegetables also imposed their own constraints. Despite being allowed to tip out of the square the images still had to sit comfortably on the stamp and also allow for the features to be stuck on the created faces. 'Other things like broccoli were shot, but didn't make the cut, which is a shame; broccoli would make fantastic hair,' recalls Johnson. The interactivity encouraged by the design of these stamps also allowed for another restriction to be 'broken'. No living person, other than a member of the royal family, is allowed to be represented on a British stamp without royal approval. What the Johnson Banks customizing design allowed was for the public to create 'cartoons' of anyone they wished on a stamp.

On another project, the British **DESIGN COUNCIL'S 2001 ANNUAL REPORT**, Michael Johnson approached photographer Philip Gatward, with whom he had never worked, but whose work Johnson had seen and admired. Johnson Banks had worked with the Design Council over a number of years and had built up a good working relationship with them as clients. The brief for this project was simply that the Design Council had to produce its annual report, which needed to emphasize their mission statement: 'Our purpose is to inspire and enable the best use of design by the UK, in the world context, to improve prosperity and well-being'.

DESIGN COUNCIL
Poster
Design Group: Johnson Banks
Client: Design Council
2001

If there were more opportunities here, they wouldn't leave www.designcouncil.org.uk

Unlike many companies wanting annual reports, the Design Council did not provide Johnson Banks with a list of that year's achievements and a series of images. After being pressed by Johnson to describe exactly what they did and to elaborate on their new mission statement, the Design Council provided Johnson Banks with a list of statistics that had had an impact on their work, such as 'By 2020 half the adults in the UK will be 50' and 'Nappies take centuries to decompose'.

Johnson Banks' solution was to create a report in two parts. The first part was the 'inspire' section, which would have photographic interpretations of the statements and statistics given to Johnson Banks. The second, 'enable', part elaborated on these, giving much more conventional annual report information. Gatward was commissioned to illustrate the first section, and in order to give the content of the photographs an authentic appearance, he appointed a model maker to create elements required for the images, such as a drain cover and a fossilized nappy.

For Johnson Banks it was key that Gatward had enough commitment to art directing and shooting the images to create all the elements in advance rather than use technology to alter the images in Photoshop. The Design Council were so pleased with the images in the annual report that they asked Johnson Banks to create a series of hoarding-sized posters to be displayed in a tunnel in Brighton which connects a hotel and conference centre, both of which were being used by politicians for a party political conference.

REBECCA AND MIKE
AIRMAIL DRESS

Like Johnson Banks, London-based design duo Rebecca and Mike (founded in 1995) are open about their close working relations with others. They say, 'Collaborators are important when they have a skill that we don't have. Why have a lesser piece of work just for the sake of giving someone some money and asking them to do something? We have no problem sharing credits.' Working with others is an extension of Rebecca and Mike's 'applied thinking' approach to design. They work closely together, 'batting things back and forth' and sharing one sketchbook. Their sketchbooks are more important than computers to their creative process. 'When we use technology it is invisible because technology doesn't define what our work is,' Rebecca Brown points out. 'If it's an end in itself you are really being dictated to by the program of the computer.'

Rebecca and Mike also invest much of their time on in-depth research of subjects relevant to the project in hand, viewing the major libraries in London as 'just as much a workspace for us as a normal office space'. A project they undertook for SHOWstudio website (an online space for leading creatives to make experimental, personal work engaging with the new fields of motion image and interactivity) about designing graphics for the gravity-free weightless environment of outer space, involved 'reading and understanding Einstein's Theory of Relativity' and working with Tracey Matthieson, a PhD programmer from Westminster University 'who brought things to the project we could never have imagined'.

Rebecca and Mike's collaborations are sometimes with their clients, as was the case with fashion designer Hussein Chalayan. The relationship initially came about after they approached Chalayan about the possibility of working with him. This is their usual approach for finding clients; they create a list of people to approach, present their portfolio and explain the way in which they like to work. Chalayan was impressed by their work and proposed collaborating on a project addressing the boundaries of packaging and product, and whether packaging could be integrated into a garment. 'I was interested in investigating the idea of creating a cyclical scenario, where people react to clothes and the end result,' recalled Chalayan. 'I like the idea of it being interactive.' [32]

AIRMAIL DRESS
Sketchbook
Design Group: Rebecca and Mike
Client: Hussein Chalayan
2002

tear paper someplace out of clothing.

Airmail

par avron

skewed square
↓
chevron

blue + red

basic alternative colours to print

adopted (as airmail was initially so small) by other countries, and then it stuck

Ethiopia

Brazil

blue paper
↓
lines
↓
to
from ········

flight

air craft

gusset envelopes.

buy it
↓
write address / and message
↓
post it
↓
receive it
↓
open it
read it
wear it

Reading writing

Ink on paper, in a code that both people understand.

Black print on manilla envelope

what is writi paper used for
① Writing letters
② Making aerop
③ Origami
④

A picture paints 1000
Words conjuring images.

he

Hello

or on a
seam

CHALAYAN

What the garments
are, and how
they could perforate
into different
garments

How they
fold up

maybe you tear it
up, then sew it

tear to open.

and seal.

The graphics on them.
shapes torn out.

dress, shirt,

jacket, top

skirt, trouser.

skirt, change length.

top,
do you need it, if you
can get it from the dress.

no change.

or maybe

or maybe

trousers, change length

dress, change to top

shirt → sleeveless
shirt

or

jacket

FFERENT
ZES

wider
longer

AIRMAIL DRESS
Design Group: Rebecca and Mike
Client: Hussein Chalayan
2002

At an initial focussed conversation, which took the place of a written brief, Chalayan explained the problems he had had with seams ripping when integrated packaging and garments were opened. Rebecca and Mike looked at possible solutions and returned to Chalayan with eleven proposals. The one that most impressed Chalayan was an **AIRMAIL DRESS**, a garment that folded out of an envelope. 'We did actually develop two garments with Hussein which folded out of the same size envelope where the envelopes were placed in different ways. With one the envelope hangs off the back and with the other it ended up as a pocket in the front.' This could become a 'garment of thoughts' – a dress that could be written on and posted or a letter that could be worn.

Since Chalayan was subject to the pressures of producing his twice-yearly collections it was some time before he returned to Rebecca and Mike with funding, from the Musée de la Mode in Paris, to create one of the garments. At this point both parties developed the area of the product for which they were best trained – Chalayan cut the dress while Rebecca and Mike worked on the print elements. As is the case with many successful partnerships, there was considerable flexibility for each party to discuss and contribute to the other's work. 'Everything was addressed down to the minutest detail,' recalls Mike. 'For example, because one particular fold is going a certain way the fold here is thicker than the printed fold line on the back with which it corresponds.'

Some of the components of the garment/package were ones that had featured in Chalayan's previous work: Tyvec (a paper fabric) used in his graduate collection and the airmail trim that referenced previous collections. Chalayan placed a great deal of trust in Rebecca and Mike's technical skills and allowed them to select the typeface (Univers) and design graphic devices such as arrows, 'based on the physics concept of harmonic motion', that indicated places to fold the garment to change its size. He also allowed them to take responsibility for the technical production of the garment because he knew that as graphic designers their knowledge of printing would ensure a smooth running process.

With this particular garment, Chalayan was keen to address the cross-over with industrial printing techniques and the appearance of commercial products. He was aware that his usual printers, used to printing fabrics for the fashion industry, would not be able to produce the required effect. Rebecca and Mike used their contacts with commercial printers to try to achieve the packaging feel. None of the industrial printers approached was able to undertake the project due to the high production cost and bespoke nature of the garment. Rebecca and Mike therefore approached Artomatic, a London-based printer who had an unrivalled reputation for creating innovative and uncompromising print and packaging solutions.

Tyvec is a notoriously difficult material to print on and Artomatic and Rebecca and Mike undertook a lot of research to ensure that the design could be printed. Artomatic also carried out a series of domestic tests to ensure that the dress could be washed. While the end product, produced in a limited edition of 300, was not as 'industrial' as Chalayan had initially hoped, it did have a suitably commercial appearance.

'RE–' MAGAZINE
Cover, issue 10
Designer: Jop van Bennekom
2003

JOP VAN BENNEKOM
'RE-' AND 'BUTT'

Magazines are a particularly clear example of collaboration, where all those involved, from stylists to photographers to editors, are contributors. Such projects are a means of involving many different skills in an end product, collaging together the skills and contributions of a vast range of specialists. Freelance Dutch designer Jop van Bennekom is involved in the production of two magazines, **RE-** and **BUTT**. As publisher as well as editor and designer of both magazines, van Bennekom has the freedom to develop them as he chooses and is not dictated to by a publishing corporation.

Building up a key group with a shared interest is the basis of the relationships for both van Bennekom's magazines. 'All the people I work with on the magazines are people I personally relate to,' van Bennekom says. While both magazines are about the combining of content and form, 'Butt' retains the same format with each issue and 'Re-' changes. Each project undertaken by van Bennekom 'looks intentionally different' and his work is not about 'style' but about 'how text, and concept in text or form get together, how they become one thing. There's always an irony and self-questioning in the work. Then it's like a style which is not only visual but which is the whole conception of the information.'

'Re-' (which van Bennekom started in 1997 as a magazine of 'daily life') is an exploration of 'what a magazine is'. It is an 'intersection of visual culture and editorial exploration' and is about 'making media and at the same time questioning media'. At first van Bennekom did everything himself. 'I wrote, edited and photographed. Design is just part of the complex process by which I try to mix all the elements into a new language,' he said. However, van Bennekom felt he needed the stimulation of working with others and now creates 'Re-' with a co-editor, Arnoud Hollermam, who also contributes to 'Butt'.

'BUTT' MAGAZINE
Cover, issue 1
Designer: Jop van Bennekom
2001

'RE–' MAGAZINE
Spread, issue 10
Designer: Jop van Bennekom
2003

'RE–' MAGAZINE
Spread, issue 23
Designer: Jop van Bennekom
2003

'Re-' is designed as a whole, with the contributors chosen before work begins and the ideas and format developed between the group. All content is commissioned specially for the magazine, and the photographers are involved in setting the briefs for their shoots rather than having them dictated by an art director or editor. Issue 10 develops the notion of a fictitious two-metre-tall model to explore the idea of media image. 'Claudia' was photographed by leading photographers Wolfgang Tillmans, Terry Richardson and Inez van Lamswerde as a 'media pastiche'. The magazine follows formats set by fashion and celebrity magazines and uses photographers who work for such publications to question those very magazines.

BUTT

Butt Number One
Fag Mag
Spring 2001

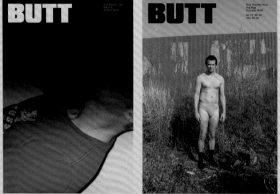

'BUTT' MAGAZINE
Covers
Designer: Jop van Bennekom
2001–4

'Butt', a 'fagazine', was started by van Bennekom and fellow editor Gert Jonkers (whom he met while working for Dutch style magazine 'Blvd') in 2000 as an antidote to the available gay magazines. It is published four times a year in an edition of 6,000, and sells for €8 (£5.50 or $10.50). They located a niche within a market and filled it with what they wanted to see. Their idea was to produce a magazine that did not conform to stereotypical ideas of gay life and was not dictated to by a large publishing house, which has increasingly become the case with the realization of the power of the pink pound/euro. Stylistically, the 'fagazine' references the DIY aesthetic of punk fanzines and, perhaps more significantly to van Bennekom and Jonkers, the cheaply produced black and white gay pornographic magazines of the 1970s.

Van Bennekom and Jonkers allow limited advertising in 'Butt', which brings in some income, but only from companies that they feel match the ideology of the magazine. In order to try and retain the aesthetic that they have created for 'Butt' they tried to encourage advertisers, such as an Amsterdam leather shop, to place twenty-year-old advertisements. When planning 'Butt' van Bennekom and Jonkers were both aware of an 'energy' in the gay world and among gay writers, illustrators and photographers, such as Wolfgang Tillmans, who did not find a platform for their work in existing commercial gay publications.

'Butt' is produced in an 'organic' way, where van Bennekom and Jonkers do little or no art directing, placing their trust in working with people who 'understand completely what it's about, where the feeling is already in their work' and 'we just try to bring it together'. One of the keys to the production of 'Butt' is the collaborative way in which van Bennekom and Jonkers work 'together like a tandem' with 'design and content being one'. The magazine is designed on a computer by both van Bennekom and Jonkers, 'so the design is very close to the editorial because we are both'.

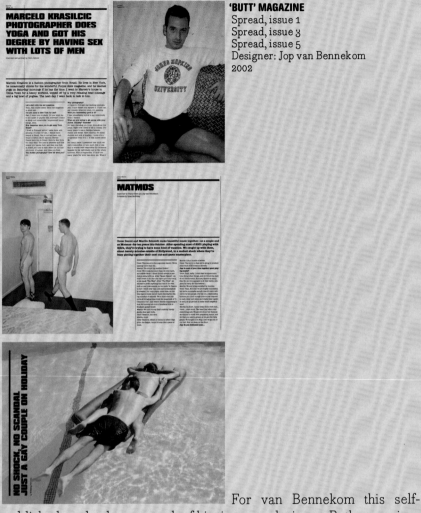

'BUTT' MAGAZINE
Spread, issue 1
Spread, issue 3
Spread, issue 5
Designer: Jop van Bennekom
2002

For van Bennekom this self-published work takes up much of his time as a designer. Both magazines sell enough copies to allow them to break even or make a small profit. However, von Bennekom does balance these publishing projects with work for clients. He admits that after concentrating on self-generated work, where he sets his own briefs, it can be difficult to undertake commissioned work as he is used to 'having complete control'. Much of his paid work comes through friends and clients within the cultural field, such as fashion designers Viktor and Rolf, the Centraal Museum, Utrecht and the Dutch Architectural Institute. He concedes that within this field the briefs are very free, with clients 'looking for a solution', and as a designer he can be 'somebody who reacts upon what they have got, and change it into something which would improve the quality of the material'.

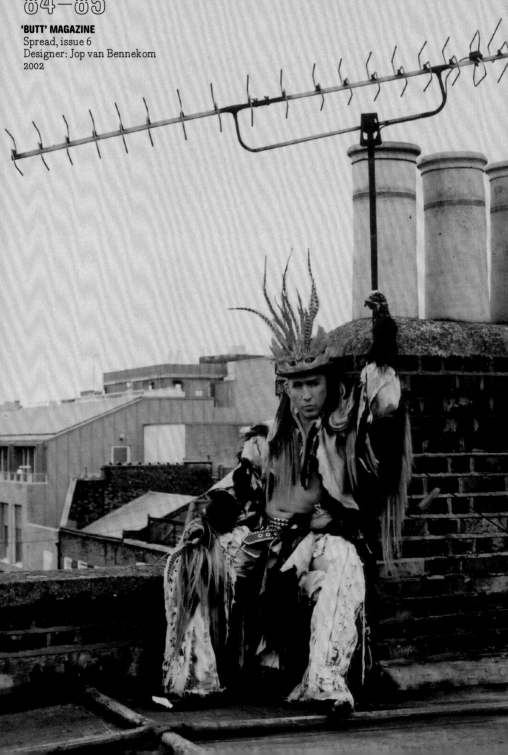

'BUTT' MAGAZINE
Spread, issue 6
Designer: Jop van Bennekom
2002

MARTIN DEGVILLE HORSE HUNG FORMER SINGER OF SIGUE SIGUE SPUTNIK HAD HIS FANTASTIC LOOKS NICKED BY GAULTIER IN THE EIGHTIES

Interview by Alex Needham
Portrait by Andreas Larsson

Martin Degville spent his pre-fame years designing and selling clothes in his shops YaYa and Degville's Dispensary, abetted by the likes of Boy George. Then he gained worldwide notoriety as a singer with Sigue Sigue Sputnik, thanks to their sole big hit *Love Missile F1-11*. These days, he's regularly seen around the gay dives of London dressed in some outlandish outfit and pouncing drunkenly upon unsuspecting teenagers. When we arranged to meet in Bar Aquida in Covent Garden, I was worried about recognising him. Needless to say, his outfit of red high heels, torn white bondage trousers, a vest bearing the slogan 'So Long Suckers' and a camouflage rucksack – all topped off with electric blue contact lenses – ensured that he still stood out a mile. He recently left Sigue Sigue Sputnik in hotly contested circumstances.

86—121
THE CHALLENGES OF THE DESIGN BRIEF

WE ARE NOT ARTISTS, WE ARE DESIGNERS AND THEREFORE HAVE TO LIVE WITH CERTAIN LIMITS AND RESTRICTIONS, BUT WE SEE THIS AS OUR CHALLENGE.

NACHO LAVERNIA, SPANISH DESIGNER

For Spanish designer Nacho Lavernia, as for many designers, the distinction between artist and graphic designer is important, as it impacts upon the way in which they approach their work. Graphic design, or commercial art as it was initially known, has traditionally been viewed as a 'lesser' creative form than art because of the commercial imperatives involved. Some designers, however, do consider their work to be art. They have a creative approach that is similar to that of an artist and are uncomfortable with the emphasis on commercial obligations. In an age of integrated communications and with the blurring of definitions between art forms, designers can make choices and are not necessarily constrained by traditional boundaries and classifications.[34]

For all designers there are the constant questions of commercial and creative within their work. In the case of client-based rather than self-initiated work, decisions and approaches about the nature of the relationship and their impact upon the work have to be considered from the outset. Many designers pride themselves on their ability to marry up a sound commercial response to their client's wishes with an expression of creativity, often 'going beyond the brief'.

The designers and projects included here illustrate various approaches that can be taken to produce successful graphic design solutions. They address the ways in which small independent studios can create exciting designs for international corporate clients, as well as for smaller clients who encourage a flexible approach to working relationships. Also considered are the ways in which self-initiated projects are balanced with commercial work and feed into the overall creativity of the design studios.

CARTER WONG TOMLIN
LOWE AND HOWIES

For London-based design consultancy Carter Wong Tomlin (founded 1984), giving something extra to their clients, and variety in their creative output and client base, are important. The variety of work is important to Phil Carter, one of Carter Wong Tomlin's two Creative Directors, because 'so often you can be pigeonholed in design. I think the nice thing with us is when people see that we can do a major corporate identity and a quirky and quite cutting-edge thing.'

Carter Wong Tomlin have undertaken rebranding projects for large multinational corporations and brands as well as projects for what could be described as 'worthy' clients or causes. Carter feels that it is important for the company to 'do some projects where people use our skills to create a difference', and notes that their work for high-paying global brands could be a 'roundabout' way of funding lower paid, 'socially aware' projects. This practice of robbing Peter to pay Paul (what critic Rick Poyner calls a 'Robin Hood tactic') has been condemned as unethical: it puts a value judgement on types of client and, of course, higher paying commercial clients still deserve to have a job well done. The counter to this is that as long as both clients get a job they are happy with, for the budget that they offer, then it is up to the designer's own moral code to make this decision.

After working with Carter Wong Tomlin on a number of projects, international agency **LOWE AND PARTNERS WORLDWIDE** approached them with a request to provide a new treatment for their existing identity typeface. 'Nothing to scare the horses,' said Adrian Holmes, Chief Creative Officer at Lowe. One of the key hurdles that designers often have to overcome in such projects is persuading a company to allow the designers to tinker with their logo. This is often the 'sacred cow' of the company's identity that the designers must work around.

LOWE
Trial drawings and final logo
Design Group: Carter Wong Tomlin
Client: Lowe and Partners Worldwide
2002

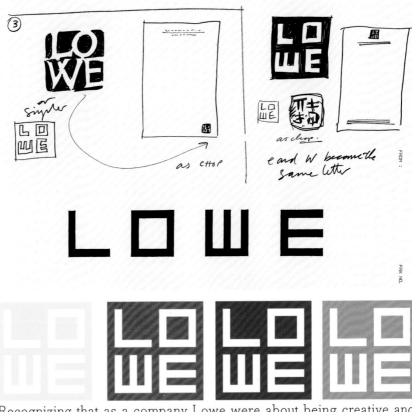

Recognizing that as a company Lowe were about being creative and taking risks, Carter Wong Tomlin felt that Lowe were missing an opportunity. They created a logo, or marque, which could be used alongside the redrawn typeface and which they felt could unite all 160 agencies in 80 countries that were part of Lowe Worldwide. The simple graphic device was inspired by the artists' seals used at the bottoms of Japanese wood engravings. Looking at the letter forms in the name, Carter Wong Tomlin realized that the 'W' and the 'E' were the same shape, and that if the letters were stacked it became a much more obvious stamp and was more practical to use. The risk they took here was that they were effectively cutting in half the name of the company founder and chairman, Sir Frank Lowe.

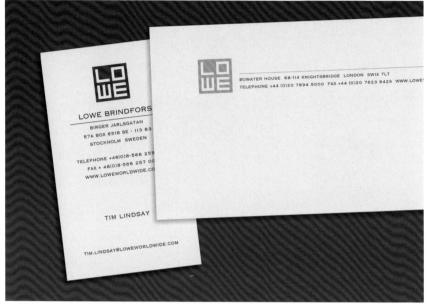

Fortunately, being a creative company, Lowe saw the irony and approved. 'It might be difficult if you were selling it to a financial organization, some other non-creative field. But they understood,' recalls Ali Tomlin, Creative Director at Carter Wong Tomlin. 'The company structure and existing corporate guidelines of clients can exert very real limitations upon a designer and project,' notes Tomlin. 'With companies like London Underground or Royal Mail, there are a lot of constraints because their guidelines as so tight. You have to use this typeface, those colours and be as creative as you can within the boundaries.'

When drawing up the logo Carter Wong Tomlin discovered that the grid was 13 x 13 squares, which meant that when it was transferred to a computer screen it was 'the perfect size for digital representation'. 'It is,' Carter observes, 'coincidences and moments like these that help you realize you have found a perfect solution.' The use of a grid formation allowed the logo to be used at any size without distortion, and Carter Wong Tomlin proposed a series of applications that included a large printed glass screen in the reception of Lowe's London office, and a digital screen, where the logo changes colour, to replace the nameplate outside the same office. For Carter Wong Tomlin, one of the key elements in this project was to take the solution beyond what was initially requested. 'Making the logo spin, that was a bonus that they weren't expecting,' says Carter. 'It's engaging the client, giving them what they require and then giving them a little bit more. That is incredibly important for us.'

LOWE
Business card and compliment slip
Design Group: Carter Wong Tomlin
Client: Lowe and Partners Worldwide
2002

LOWE
Website
Design Group: Carter Wong Tomlin
Client: Lowe and Partners Worldwide
2002

Carter Wong Tomlin understood the challenge of uniting a large international company and rather than try to force one colour onto all the parts of Lowe they created a palette of colours that could be applied to the logo and typeface to allow each subsidiary to retain its own identity, as well as conforming to corporate company guidelines. One of the key considerations was to create an identity that could be embraced by all the associate offices across the world. Some of these companies, such as Lowe Alice in France, had strong identities and colours that were associated with their brand regionally.

The palette of colours the designers proposed incorporated a master identity of light blue for the central worldwide offices (London and New York), together with a supporting palette for the remaining agencies, which allowed Lowe Alice to continue using their yellow. Carter believes that an important element of creating any identity is understanding that 'you can create an identity but you must also find a way of getting the people in the company to want it and embrace it'.

HOWIES
T-shirt packaging
Design Group: Carter Wong Tomlin
Client: Howies
2002

Lowe were so pleased with the identity that they commissioned Carter Wong Tomlin to redesign their website. The Lowe website acted as a launch pad for their new identity and a showcase for the network's creative work. Having initiated the box device, Carter Wong Tomlin used this as the basis for the visual appearance of the website, incorporating it into the navigation, the maps and the introductory animations. New media work is not anything special for Carter Wong Tomlin. 'The fact that it is part of the package is just another way of putting the branding across,' says Ali Tomlin. Carter Wong Tomlin have two designers who specialize in new media, but in order to fully deliver the Lowe website, and accompanying intranet site (which allowed all Lowe companies easy access to the new branding guidelines), they worked with specialists who could develop the level of technical specifications required by the proposal. Having a range of skills within the studio is a key to Carter Wong Tomlin's success, as is their open approach to running their studio. 'We believe in hard work, but creative solution and thought don't just happen between 9 and 5,' observes Carter. 'If people don't go home at 6.30, when are they going to see films and do things which are going to feed into their creativity?'

Self-initiated projects are important to Carter Wong Tomlin both to allow the staff to explore new creative ideas and as an advertisement for work. '1057', a book of photographs of bike-lane symbols, is often left as a gift for potential clients; it acts as a complement to the company brochure and 'says a little bit more about us than perhaps the last job did'. After seeing a piece of guerrilla advertising by Howies,[35] Phil Carter sent them a copy of '1057' thinking that it would appeal to their ethical and environmental stance. Howies were impressed and asked Carter Wong Tomlin to design some packaging for their products.

HOWIES is a small, family-run company based in Wales producing organic cotton T-shirts aimed at skateboarders and cyclists. They originally operated as a mail order business, but were increasingly selling their T-shirts through retail outlets and needed to develop new packaging. Their brief to Carter Wong Tomlin was simple: the packaging should be cost effective and environmentally friendly, should not add anything to the cost of the T-shirts, and one package had to cover all the designs and all the sizes. The budget was small but, as Howies' co-founder David Hieatt points out, 'Even if we can't afford big budgets then we can afford for Carter Wong Tomlin to be brave.'

The solution was found in Italy in a natural brown paper bag made for the Dutch flower-bulb market. The bag had a mesh-covered aperture (intended to allow the bulbs to aerate) through which the T-shirt could be seen. An image of each T-shirt design was rubber stamped onto the outside of the bag and a hole-punch arrow was used to clip the bag to indicate different sizes. Two photographs taken by Carter, one of a skateboarder using abandoned wardrobes as a ramp, the other of his son on a bike, were used on either side of the bag to allow it to appeal to both target audiences.

Such was the success of this design solution that Howies asked Carter Wong Tomlin to design new points of sale for the larger outlets carrying their T-shirts. Carter Wong Tomlin once again responded with an unexpected solution, utilizing an existing 'product'. They proposed using abandoned wardrobes of the kind previously illustrated on the T-shirt packaging, used by skateboarders and bikers as ramps. Thirteen artists and illustrators, some of whom had worked with Carter Wong Tomlin on previous projects, were approached and asked to decorate the wardrobes.

HOWIES
Point of sale wardrobes
Design Group: Carter Wong Tomlin
Client: Howies
2003

Once again Howies had a limited budget and Carter Wong Tomlin used networking and social opportunities to persuade the illustrators to undertake the work. Jeff Fisher, for example, was co-opted during a judging session for the D&AD (British Design and Art Direction) Awards, where Carter persuaded him over a drink. 'I was able to pull him into doing it with a bottle of whisky. He kept his word and came over and did it, along with Paul Davies.' The artists chose the themes for their work from a list of issues important to Howies, from Junk Mail to GM foods, Fish Farms to Mass Consumerism.

After submitting an initial design to allow Carter Wong Tomlin to select the appropriate wardrobe, the artists created their designs while 'in residence' at Carter Wong Tomlin's studio. The wardrobe for Andrew Mockett, for example, had to be solid wood rather than veneer to allow him to carve his design into it. The wardrobes, Tomlin notes, became 'irreverent and provocative icons of a company that is in the business of making us think about the damage we are doing to the environment'.

The publicity around this creative project did act, like the self-generated '1057' book, as an advertisement for Carter Wong Tomlin. As a result of this work they were approached by a number of potential clients, including a local plumber who required new business cards, and Jake Scott, son of film director Ridley Scott, who asked them to design a wedding invitation which they undertook with one of the wardrobe illustrators, Brian Cairns.

Both Carter Wong Tomlin's new identity for Lowe and their work for Howies have won several design awards. While this is by no means a primary reason for undertaking work, entering awards has been part of the company's philosophy since its founding. Carter feels it is important for two reasons: being seen by peers as a creative group, and marketing the company to potential and existing customers, 'especially if the award is the Design Business Associations' Design Effectiveness Award as it shows the effectiveness of good design in hard commercial terms'.

MOTHER
BRITART.COM

Web-based company **BRITART.COM** was conceived as a way of encouraging the public to buy art by British artists. The company's key aims were to encourage people to buy good-quality original art at reasonable prices and undermine the elitism associated with art galleries, which was putting many people off buying art. Britart.com approached London-based advertising agency Mother (established 1996) to create a campaign to raise awareness for the website and also to look at the branding and logo of the company.

The first part of the project Mother dealt with was the logo. 'We came up with a graphic device which incorporated the dot.com but also made a joke of the sold red dot sticker used in art galleries. In a way it was a mnemonic for what they did,' recalled Mother's Kerry Millet. As the budget for the britart.com campaign was small, Mother had to conceive original ideas that would raise the profile of the company. Low-cost, ready-made and cheap solutions needed to be found for some parts of the campaign. This allowed Mother to spend what money there was on the company's headed stationery and 'gimmicks', such as 'preview glasses' that allow the wearer to see how art would look on their walls, which were sent to opinion formers and journalists as a means of generating press interest. As a way of encouraging potential art buyers into rethinking the nature of art, Mother devised a series of art plaques that turned everyday objects such as pavements, walls and trees into pieces of art. To keep printing costs down the art plaques were typeset and photocopied by Mother onto Avery sticky labels, where the sizes of the labels determined the sizes of the plaques. To overcome the problem of getting colour onto a black and white photocopy, red stickers were bought off the peg and stuck onto the photocopies.

BRITART.COM
Logo before redesign

britart.com

BRITART.COM
Logo
Agency: Mother
Client: britart.com
2001

britart.com

ART PLAQUE
In situ
Agency: Mother
Client: britart.com
2001

Railing 1971

metal rods, paint.
300 x 100 x 5cm

The barrier in context.
A metaphor for the 21st-century nanny state.

art you can buy **britart.com**

Bridge 1977

bricks, steel, railway line.
60545 x 1025cm

Railway line: kind donation from Railtrack plc.

art you can buy **britart.com**

In distributing the art plaques both designer and client risked prosecution, as the plaques were illegally fly posted onto the objects they described. 'We knew it was illegal and the client knew it was illegal but they were great,' says Millett. 'Some people call it littering but it was the only way to do this and I believe that when things are done in the right way they decorate.' The britart.com campaign was, along with the work of maverick graffiti artist/graphic designers such as Banksy, one of a number that prompted debate in the British graphic design press about the responsibility of fly posting and graffiti-based graphic design that appeared across London.

Mother do not accept that any brief they are handed is 'a given' until they have done some investigation. 'We might argue for the first week about whether we think the brief is appropriate or not and whether we think they are going after the wrong thing,' says Cecilia Dufils, one of Mother's creatives. This questioning is a means of beginning to seek the 'solution' to the client's 'problem'. During this questioning and throughout the whole design process, the creatives at Mother work closely with the client to ensure that the client has a chance to put forward their own ideas and that 'we don't surprise anyone at the end'.

MOTHER
Studio, London

At Mother the creatives are personally accountable for the decisions they make on a project, as happens in smaller design agencies. This differs from the conventional practice in advertising agencies where account managers are usually responsible for direct communication with the client. The traditional advertising division of creative teams into art directors or copywriters is discouraged in favour of a mixing of skills in their creatives. On any Mother project there will be four elements to the team developing the ideas and campaigns, as Kerry Millet explains, 'The mother, that's me, who deals with production and logistics, a strategist, more usually known as a planner, who would deal with such matters as background data, the creatives and, very importantly, the client.'

Mother pride themselves on their unconventional arrangements in terms of both working practices and office arrangements. All work takes place in a large, open-plan office with areas of soft seating set aside for breakout meetings. Staff move desks every two weeks and all disciplines are mixed up to 'prevent ghettos of one discipline not talking to another'. This creative approach, according to Marcus Bjurman, 'encourages active dialogue and interesting cross fertilization of ideas'. It is the agency's 'unconventional approach' to their own working process and environment as well as their 'challenging design and advertising campaigns', Millet believes, that attract clients to them.

CALENDAR
Design Group: Studio Anthon Beeke
Client: Flevordruk Harderwijk
2003

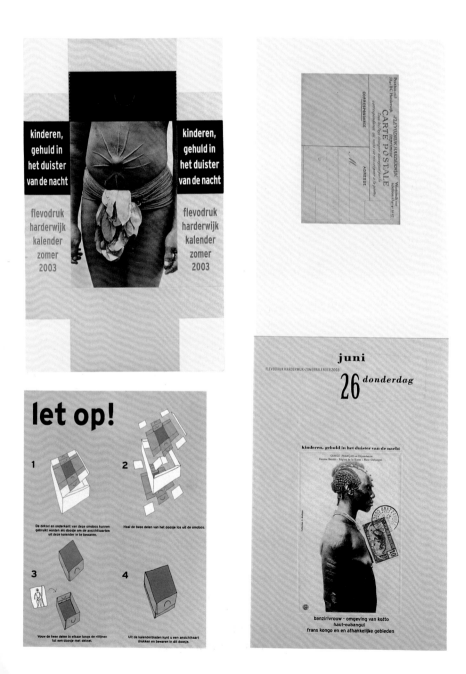

STUDIO
ANTHON BEEKE

FLEVORDRUK
HARDERWIJK
AND 'BLOOM'

Although best known for his controversial and world-famous posters for museums and theatre groups, Dutch designer Anthon Beeke's work covers all fields of graphic design, from corporate identities to books and packaging. His work, he feels, is about 'over-turning conventions and diminishing the distinction between function and decoration'. Thus he likes his clients (who are drawn from the commercial as well as the cultural field) to remain open to alternative solutions. Sometimes 'They ask me for a book and I come with an exhibition,' he confesses, noting that this may ultimately answer the client's demand in a more fulfilling way than giving them the specific product initially requested.

For Beeke trust in a working relationship, with both clients and collaborators, is key. In 2002 a print company that Beeke frequently uses to print his work because of their open, 'can-do' problem-solving attitude approached Studio Anthon Beeke as a client. Flevordruk Harderwijk wanted Beeke to design a series of **CALENDARS** that could be used as gifts for their clients, a practice common among printers. They approached Beeke because of the way in which he tackles his projects. The brief stated that Beeke could do whatever he wanted as long as the calendars were produced four times a year and would hang on the wall. For Beeke it was important to make a statement as well as providing the dates, 'otherwise why would anyone put it on the wall?'

The three calendars Beeke has designed have each challenged notions of traditional calendars, but have also provided the users with something beautiful at the end of the calendar's period, ensuring they remember the printer. The first calendar featured images from Beeke's own collection of clothes hangers, printed onto different weights and sizes of paper, playing with the client's request for something to hang on the wall.

CALENDAR
Design Group: Studio Anthon Beeke
Client: Flevordruk Harderwijk
2003

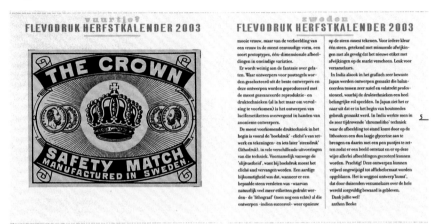

vuurtjes?
FLEVODRUK HERFSTKALENDER 2003

zweden
FLEVODRUK HERFSTKALENDER 2003

mooie vrouw, maar van de verbeelding van een vrouw in de meest eenvoudige vorm, een soort prototypes, één-dimensionale afbeeldingen in oneindige variaties. Er wordt weinig aan de fantasie over gelaten. Waar ontwerpers voor postzegels worden geselecteerd uit de beste ontwerpers en deze ontwerpen geproduceerd met de meest geavanceerde reproduktie- en druktechnieken (al is het maar om vervalsing te voorkomen) is het ontwerpen van luciferetiketten overwegend in handen van anonieme ontwerpers.

De meest voorkomende druktechniek in het begin is vooral de 'boekdruk' -cliché's van zetwerk en tekeningen- en iets later 'steendruk' (lithodruk), in vele verschillende uitvoeringen van die techniek. Voornamelijk vanwege de 'slijtvastheid', want bij boekdruk moest het cliché snel vervangen worden. Een aardige bijkomstigheid was dat, wanneer er een bepaalde steen versleten was -waarvan natuurlijk veel meer etiketten gedrukt werden- de 'lithograaf' (toen nog een echte) al die ontwerpen -indien succesvol- weer opnieuw

op de steen moest tekenen. Voor iedere kleur één steen, getekend met minuscule afwijkingen met als gevolg dat het nieuwe etiket met afwijkingen op de markt verscheen. Leuk voor verzamelaars.

In India alsook in het grafisch zeer bewuste Japan werden ontwerpen gemaakt die balanceerden tussen zeer naïef en volstrekt professioneel, waarbij de druktechnieken een heel belangrijke rol speelden. In Japan ziet het er naar uit dat er in het begin van houtsnedes gebruik gemaakt werd. In India werkte men in de zeer tijdrovende 'chromolitho' techniek waar de afbeelding tot stand komt door op de lithosteen een dun laagje glycerine aan te brengen en daarin met een pen puntjes te zetten zodat er een beeld ontstaat en er op deze wijze allerlei afbeeldingen gecreëerd kunnen worden. Prachtig! Deze ontwerpen kunnen vrijwel ongewijzigd tot afficheformaat worden opgeblazen. Het is weggooi ontwerp 'kunst', dat door duizenden verzamelaars over de hele wereld zorgvuldig bewaard is gebleven.

Dank jullie wel!
anthon beeke

The other two calendars continued the idea of utilizing collections and encouraged the user to take them apart and save the pieces. These could be constructed into a book of images of matchboxes in one case and a box of early twentieth-century anthropological photographs of Africa in the other. By designing each calendar in a different format, Beeke was creating an opportunity for Flevordruk Harderwijk to showcase their skills in a variety of printing methods. The freedom of the brief for this project allowed Beeke to introduce an element of his own personal passion into the project and this has reflected on both the client and the relationships that the client is building by giving Beeke's calendar as a gift.

Like fellow Dutch designer Jop van Bennekom, Beeke is involved in the production of a magazine in an entrepreneurial way, creating his own product, doing his own sales and to an extent distribution. Working in this way allows him the creative freedom (within the confines of a particular end product) that he thrives upon. **BLOOM**, 'the first trend magazine for flowers and plants and how they relate to fashion, interiors and other industries', is designed and art directed (along with Manon Schaap and Paris-based fashion forecaster, Lidewij Edelkoort) by Beeke, and published by United Publishers S.A. (run by Beeke and Edelkoort). It is free from the dictates of corporate magazine publishing, and Beeke's

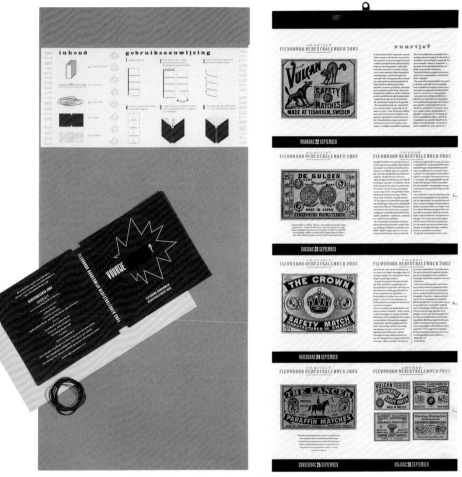

team determine the style and content of the magazine. 'Bloom' is published twice a year (in May and November) in a print run of 8,000. It is a relatively expensive magazine, selling for £36 (€52 or $67), with the majority of sales being made through subscription. The cost allows the company to make enough money to keep the magazine running and, perhaps more crucially, allows them to produce the magazine without commercial advertising (except for gift-type inserts), which Beeke believes would compromise the art direction and design. The team who work on the magazine (who also work on View on Colour, a fashion-trend forecasting magazine from which 'Bloom' was born) conceive the ideas together, but are guided strongly by the trend forecasting of Edelkoort.

BLOOM
Detail, issue 10
Design Group: Studio Anthon Beeke
Client: United Publishers S.A.
2004

animal flower

With its fangs, exotic stripes and hairy petals,
one expects the Huernia to roar. Indeed, it seems
more fauna than flora. Despite appearances,
the Huernia is a succulent plant, growing in the arid
regions of the globe, such as Eastern and Southern
Africa, Arabia, and the Southwestern USA.
The plant itself, measuring 10 fleshy centimetres
in height, is armed with large teeth, and, though
it is hardly carnivorous, its blossoms emit an odour
of decaying carrion. The Huernia's almost animal
characteristics have evolved over time; growing
in deserts where butterflies and bees are rare,
the furriest, strongest-smelling flowers were able
to attract flies and wasps to pollinate them:
survival of the fittest.

photos **Daniel Schweizer**

BLOOM
Cover, issue 10
Design Group: Studio Anthon Beeke
Client: United Publishers S.A.
2004

'Bloom' draws from the language of horticulture to offer a new and stimulating way to view predictions in design styles and colour trends. It is primarily a visual magazine with very little text, allowing the images to speak and to dictate the ideas. Art Director Manon Schapp explains, 'We have to dive into the image to get the feelings, emotions and tactility. The graphic design has to grow out of the image.' Beeke feels this approach is important for the consumers (more usually in the fashion and design industries than horticulture) of the magazine, allowing them to appreciate the colours and textures rather than a written ideology.

Schapp challenges her photographers by asking them to work outside their usual fields, for example asking a fashion photographer to shoot flowers. To keep the magazine fresh and visually interesting, Schapp and Beeke search constantly for new photographers. 'We have pictures from recently graduated photographers, where only one photograph has grabbed my attention but I feel they have something.' Schapp feels that using the work of these young photographers is an opportunity for them to expose their work to new audiences. The cover title and titles of sections in the magazine are in a 'handwritten script' designed by Beeke. According to Beeke, this element is used to 'reflect the handwriting of those who create the magazine and the emotions that are involved in writing a letter. The picture and the handwritten text together creates a mood.'

Beeke believes that as the graphic design profession develops and new technology is available to printers it is increasingly possible for both the designer and the printer to learn from each other. It is key, he believes, to work with people 'that you trust, who understand your design and believe in doing the best job possible'. Having built up a reputation over a long career in the graphic design industry allows Beeke to 'indulge his passions' in his designs, something that his clients are aware of and attracted to when inviting him to work for them. He is conscious that after thirty years his work is recognizable. 'The house style is more or less the mentality. In my posters there is a way of speaking to the audience that they understand, that makes my posters very recognizable.'

Beeke employs a range of designers from a variety of backgrounds in his studio, in order to 'provide clients with a direct solution to their brief if they request that' as well as to allow him to both teach and learn from those working with him. Beeke also teaches in a formal capacity and is head of the Man and Communication Department at the Design Academy in Amsterdam, a role he feels is important for him to make a contribution to the future of the graphic design industry. Discussing the set-up of his studio, Beeke highlights the difficulty of keeping staff when so many designers want to set up their own practices. After a long and successful career as a freelance designer, he understands the need for young designers to express their creative freedom and work for themselves, just as he set up his own design studio after a spell as Assistant Director of renowned Amsterdam design firm Total Design.

BLOOM
Spreads, issue 8
Design Group: Studio Anthon Beeke
Client: United Publishers S.A.
2004

KUNTZEL+DEYGAS
CATCH ME IF YOU CAN

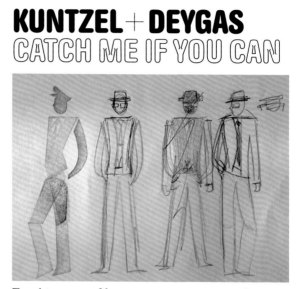

For his 2003 film **CATCH ME IF YOU CAN**, director Steven Spielberg broke his own tradition of not having separate opening titles. He decided that approaching an innovative animation graphics company would offer him a creative solution to his desire for a unique title sequence. Because the film was set in the 1960s, Spielberg wanted the titles to have the feel of a 1960s film, and he approached London-based animation production company Nexus Productions (whose work Spielberg and DreamWorks producer Walter Parkes had seen in an airline safety film for Virgin Airlines) with a brief to produce a three-minute opening sequence. Nexus sent a showreel of the designers they represent and Spielberg and Parkes chose three, who were asked to respond to the brief. The winning scheme was a highly crafted traditional animated route by French design duo Kuntzel+Deygas (Olivier Kuntzel and Florence Deygas).[36]

Kuntzel + Deygas responded to the period setting of the film by referencing 1960s film graphics, such as those by Saul Bass. Kuntzel recalls that initially they were tempted to create a complex, computer-based animated solution that they felt would challenge them, but decided against this. 'It was interesting to sell to Spielberg something very low tech. Because he had all the companies able to do computer graphics, we felt we had to impress Spielberg by doing something that uses a very simple technique.'

CATCH ME IF YOU CAN
Sketch of figures
Directors: Kuntzel+Deygas
Production: Nexus Productions
Client: DreamWorks
2003

CATCH ME IF YOU CAN
Character stamp
Directors: Kuntzel+Deygas
Production: Nexus Productions
Client: DreamWorks
2003

CATCH ME IF YOU CAN
Stamped figures
Directors: Kuntzel+Deygas
Production: Nexus Productions
Client: DreamWorks
2003

What Kuntzel+Deygas created was not a copy of 1960s film graphics, but a new film that was in the spirit of the period. 'We didn't look at any 1960s titles,' explains Kuntzel. 'We just tried to work as though we were in that period, the way we imagined designers in the sixties worked with paper, with music, with pleasure, with no pressure.'

Kuntzel+Deygas are renowned for their character-based animation for music videos and advertising, an integral aspect of their work that they brought to the 'Catch Me if You Can' titles. They created the characters for the cat-and-mouse-type chase, which mirrored the chase between FBI Agent Carl Hanratty and forger Frank Abagnale in the film, using carved architect's erasers (a method they have successfully used on other projects). These stamped characters were then scanned into the computer, and animation software was used to integrate them into the overall graphics.

CATCH ME IF YOU CAN
Test still
Directors: Kuntzel+Deygas
Production: Nexus Productions
Client: DreamWorks
2003

The scene into which the characters are placed is 'like a bar code' that utilizes the text of the titles to create vertical lines, allowing for what Nexus co-founding producer Charlotte Bavasso describes as a 'very classic cartoon device', where the characters hide behind the lines and 'reveal themselves to develop the story'. Blending text, lines and simple silhouettes was the key for Kuntzel+Deygas. Making the images move from left to right reflected the 'way that we read', and the graphics are, Kuntzel explains, 'a sort of melting between typography and hieroglyphs, where the text becomes objects and the graphic devices tell the story.

The use of hand-stamp animation gave the titles an economic elegance, but behind the apparent simplicity lay a complex production process and a strict set of legal conditions that had to be followed. Kuntzel+Deygas were required to be aware of certain contractual stipulations between the actors and the film studio, particularly those that related to the size and order of the names of the lead actors in the film. 'The contract was so important, with the size and the timing being the biggest problems,' notes Chris O'Reilly, co-founder of Nexus Productions. 'There had to be sixty names on the screen and so Kuntzel+Deygas had to have movement but at the same time get the timing just right. There was no question of removing a name.'

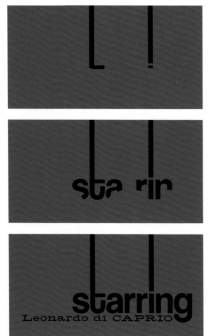

In order to comply with these provisos, Kuntzel+Deygas developed two sets of typefaces for the names and functions of those involved in the film. Initially the connecting 'bar-code' lines were created from the functions, such as 'directed by' with the corresponding names – 'Steven Spielberg' – in a fifties-style type. However, Kuntzel + Deygas quickly realized that the graphics would have to be translated for non-English language release and reshaped to television format for the DVD and video release. By using the names for the connecting lines, Kuntzel noted, 'we had the same pattern and were able to just change the function'.

Internet-based communication played a large role in the design process and Kuntzel+Deygas did not actually meet Spielberg and Parkes until the film premiere. Using software such as Photoshop and Illustrator allowed Kuntzel + Deygas to send images over the Internet, and they received MP3 sound files that allowed them to hear the score that John Williams had written for their opening titles of the film. In order to be able to see what the finished effect of the graphics would be like on a cinema screen, Kuntzel + Deygas invested in an expensive new projector and screen. This ensured that when they sent their graphics to the United States and they were viewed on a large screen, the client would be seeing what the designers were seeing, which would avoid the designers having to resize at a later date and risk altering the feel of the graphics.

CATCH ME IF YOU CAN
Initial format for film titles
Directors: Kuntzel+Deygas
Production: Nexus Productions
Client: DreamWorks
2003

Because of the strict legal requirements for running a business in France, it is most economic for Kuntzel+Deygas to operate as two freelance designers working together (they are also joint directors of a company, Add-A-Dog, which they use to pay the rent on the studio and buy equipment). They benefit from being represented by a producer, Nexus, who not only finds work for the designers but also interprets briefs and takes on day-to-day aspects of the work, allowing them to work uninterrupted – which they did for three months on 'Catch Me if You Can'.

When they have a large job or jobs that require particular skills outside their capabilities, Kuntzel + Deygas employ other freelance designers who work in their large studio, which is equipped with a variety of PC and Macintosh computers and an editing suite. On 'Catch Me if You Can' they worked very closely with Deygas's sister, Agnès Fauve, an animation expert who helped bring the characters to life, and a team of visual effects experts who, under the supervision of Patrice Maugnier, used software such as Discreet 3ds max to create the animation loops and extra elements such as cars and bubbles in a swimming pool.

CATCH ME IF YOU CAN
Stills
Directors: Kuntzel+Deygas
Production: Nexus Productions
Client: DreamWorks
2003

KUNTZEL + DEYGAS
Office, Paris

For Kuntzel + Deygas, blending techniques is a key to their creative process. As partners both in work and in their private life, they have developed a close working relationship that allows them to explore their own interests and collaborate with others when projects require this. Balancing commercial projects with personal projects is key to Kuntzel + Deygas's creative output. Kuntzel points out that it is important within the moving graphics world, where free pitching is common, not to 'spend too much energy on competitions' that may have no positive outcome, especially as this can detract from the projects which allow a designer to explore personal passions.

One long-standing project that has proved lucrative for Kuntzel + Deygas is **WINNEY**, their cartoon bull. Winney is an experiment in the development of a character and the design process behind that development. Showing this work to clients has led to profitable collaborative relationships with French design shop Colette, Evian water, Baccarat crystal and Sony.

Reflecting on the process of design involved in the creation of both the 'Catch Me if You Can' graphics and Winney, Kuntzel believes that, 'The [graphic design] press consider a lot of graphic designers in the same way as artists, but agents and clients do not necessarily see this side, they see you as just a technician. The only way to continue to exist and to explore the ideas we are passionate about is to be considered as artists rather than technicians.'

WINNEY
Design Group: Kuntzel+Deygas
2002–3

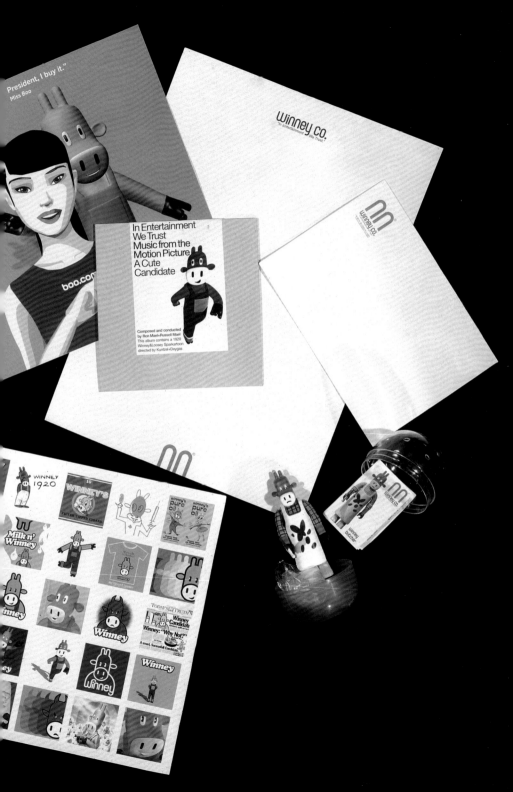

'RE–' MAGAZINE
Cover, issue 23
Designer: Jop van Bennekom
2003

DIALOGUE: THE FUTURE OF GRAPHIC DESIGN

Graphic design is a dynamic, fast-paced industry that covers a range of disciplines. It sits at the intersection of many other creative practices, from fashion to architecture to film-making. In the first few years of the twenty-first century, graphic design has become more open to new approaches than ever before. There has been a steady growth in small independent 'boutique' studios, some of which attract high-profile commissions from global clients. There has also been a growth in integrated communications groups. As stated in the introduction, at and between these extremes the graphic design industry supports a wide range of jobs and roles, not just the seemingly most obvious one of creative designer producing work. This variety of roles and structures reflects the complexity of client and designer relationships.

The practice of graphic design is also called visual communication, and as the interviews conducted for this book suggest, communication is one of the key unifying factors within graphic design practice. Clear dialogue between all parties involved in the creation and production of a piece of graphic design, from the client, through collaborators and producers to the end user is one of the distinguishing factors of contemporary graphic design. This communication is the underlying factor that allows for successful relationships within graphic design and will ensure the future of the industry.

© Re-Magazine #23
Spring 2007

Re-Magazine
Established 1997

NL / B / D - €9,00
F - €9,50
UK - £5.95

IT'S SPRING
TWO THOUSAND SEVEN
(2007)

123
FURTHER RESEARCH

Considerable information on graphic design can be found in design magazines such as Design Week, Creative Review, Emigré, Eye and Graphis. There are a number of publications such as 365: AIGA Year in Design, Art Directors' Club of Europe Annual and D&AD Annual which offer an annual round-up of the 'best' in graphic design and advertising. The following books are also useful.

Austin, Jane (ed.),
The Graphics Book,
RotoVision, Hove,
East Sussex, 2002

Bierut, Michael et al (eds),
Looking Closer:
Critical Writings on
Graphic Design,
Allworth Press,
New York, 1994

Bierut, Michael et al (eds),
Looking Closer 2:
Critical Writings on
Graphic Design,
Allworth Press,
New York, 1997

Bierut, Michael et al (eds),
Looking Closer 3:
Classic Writings on Design,
Allworth Press,
New York, 1999

Bierut, Michael et al (eds),
Looking Closer Four:
Critical Writings on
Graphic Design,
Allworth Press,
New York, 2002

Bonnici, Peter
Visual Language:
the Hidden Meaning of
Communication,
RotoVision, Hove,
East Sussex, 1999

Burgoyne, Patrick,
GB: Graphic Britain,
Laurence King,
London, 2002

Catterall, Claire,
Specials,
Booth Clibborn Editions,
London, 2001

Fiell, Charlotte and Peter,
Graphic Design for the
Twenty-First Century,
Taschen,
Köln and London, 2003

Fletcher, Alan,
The Art of Looking
Sideways,
Phaidon,
London and New York, 2001

Heller, Steven and
Karen Pomeroy,
Design Literacy,
Allworth Press,
New York, 1997

Heller, Steven,
The Education of a
Graphic Designer,
Allworth Press,
New York, 1998

Heller, Steven,
Design Literacy
(Continued): Understanding
Graphic Design,
Allworth Press,
New York, 1999

Holland, DK,
Design Issues: How Graphic
Design Informs Society,
Allworth Press,
New York, 2001

Hollis, Richard,
Graphic Design:
A Concise History,
Thames and Hudson,
London, 2001

Küsters, Christian
and Emily King,
Restart: New Systems in
Graphic Design,
Thames and Hudson,
London, 2001

Lupton, Ellen, Donald
Albrecht, Susan Yelavich
and Michael Owens,
Inside Design Now,
Laurence King,
London, 2003

Meggs, Philip B.,
A History of Graphic Design,
John Wiley and Sons,
New York, 1988

Newark, Quentin,
What is Graphic Design?,
RotoVision, Hove,
East Sussex, 2002

Odling-Smee, Ann,
The New Handmade
Graphics: Beyond
Digital Design,
RotoVision, Hove,
East Sussex, 2002

Plazm, 100 Habits of
Successful Graphic Designers,
Rockport Publishers Inc.,
Gloucester,
Massachusetts, 2003

Poyner, Rick, Communicate:
Independent British Graphic
Design since the Sixties,
Laurence King,
London, 2004

Rock, Michael,
'The Designer as Author',
in Eye, vol.5, no.20
(Spring 1996), pp.44–53

NOTES

All quotations in the text, unless otherwise stated, are based on interviews with the author.

1. DK Holland, Design Issues: How Graphic Design Informs Society, Allworth Press, 2001, p.vii.

2. Tibor Kalman, J. Abbott Miller and Karrie Jacobs, 'Good History/ Bad History', in Bierut et al, Looking Closer: Critical Writings on Graphic Design, p.27.

3. This trend was identified and discussed in depth in Anne Odling-Smee, New Hand Made Graphics, RotoVision, 2003.

4. Lorraine Wild, quoted in Quentin Newark, What is Graphic Design?, RotoVision, 2002.

5. Quoted in Mike Dempsey, 'Just the Type', Design Week, vol.17, no.30 (25 July 2002), p.19.

6. Maggie McNab, 'Crisis as Opportunity: Creating Revolutionary Thinking', in D. K. Holland, Design Issues: How Graphic Design Informs Society, Allworth Press, 2001, p.133.

7. Misha Black, 'The Designer and the Client' (address to Sixth International Design Conference, Aspen, 1956). From the archives of IDCA (International Design Conference Aspen), quoted in Bierut, Michael, Looking Closer 3: Classic Writings on Design, Allworth Press, 1999, pp.110–11.

8. Quoted in Michael Bierut, William Drenttel, Steven Heller and D. K. Holland, Looking Closer 2: Critical Writings on Graphic Design, Allworth Press, 1997, p.172.

9. Quoted in Quentin Newark, What is Graphic Design?, RotoVision, 2002.

10. Quoted in Paula Carson, 'Self-Determination', Creative Review, vol.23, no.12 (December 2003), pp.52–6.

11. The manifesto was first delivered at the Institute for Contemporary Arts in London in November 1963.

12. Michael Rock, 'Can Design be Socially Responsible?' in Bierut, Michael, Looking Closer: Critical Writings on Graphic Design, Allworth Press, 1992, p.192.

13. Discussed in keynote lecture at GraficEurope conference, 2003.

14. Quoted in 'Cause and Effect: Design for Social Causes', by Jacques Lange on www.icograda.com

15. Larry Keeley, 'Design for a Time of Weird, Wild Change', in DK Holland, DesignIssues: How Graphic Design Informs Society, Allworth Press, 2001, pp.216–17.

16. Milton Glaser's Road to Hell is reproduced in Creative Review, vol.23, no.12, p.56.

17. Ellen Lupton, 'The Producers', in Inside Design Now, Ellen Lupton, Donald Albrecht, Susan Yelavich and Michael Owens, Laurence King, 2003, p.23.

18. Ibid. See also Rock, Michael, 'The Designer as Author', in Eye, vol.5, no.20 (Spring 1996), pp.44–53.

19. Natalia Ilyin, quoted in Bierut, Michael et al, Looking Closer 2: Critical Writings on Graphic Design, Allworth Press, 1997, p.38.

20. Quoted in Richard Clayton, 'D&AD's career plan is still work in progress', Design Week, vol.18, no.25 (19 June 2003), p.12.

21. Linda Relph-Knight, 'Invest in training staff, but include yourself as well', Design Week, vol.17, no.22 (30 May 2002), p.4.

22. Independent British designers and design studios are studied in depth in Rick Poyner, Communicate: Independent British Graphic Design since the Sixties, Laurence King, 2004.

23. WPP also includes advertising agencies such as Ogilvie and Mather, JWT (J Walter Thompson) and Y&R, and employs around 55,000 staff overall. There are both benefits and downsides to being part of a larger umbrella organization. It can allow for an ease of collaboration with complementary companies. On the Kotex project, Coley Porter Bell collaborated closely with Ogilvie and Mather on an integrated approach to design and advertising. They also regularly turn to WPP stablemates Research International and the Henley Centre for assistance on research into product or brand development. There can be a convenient sharing of clients, and for clients looking for an integrated approach and not just pure design it can prove beneficial. However, decision making can be determined outside the company, imposing regulations that are determined by the parent body. 'If, for example, we wanted to work for a political party or an overseas government in any capacity,' commercial director Martin Sanders explained, 'we would need to talk to them first, and they would have to sanction that.'

24. Quoted in Laurel Harper, Radical Graphics/Graphic Radicals, Chronicle Books, 1999, p.7.

25. Quoted in Liz Farrelly, 'Publish and Be Saved', Blueprint, no.208, June 2003, p.50.

26. Quoted in Paula Carson, 'Design for Life', in Creative Review, vol.23, no.4 (April 2003), p.46.

27. Anne Odling-Smee, New Hand Made Graphics, RotoVision, 2003, p.94.

28. Larry Keeley, quoted in DK Holland, Design Issues: How Graphic Design Informs Society, Allworth Press, 2001, p.212.

29. Quoted in Yolanda Zappatera, 'Print Works', Design Week, vol.18, no.4 (23 January 2003), p.22.

30. The Chase (London) has four members of staff, all designers, equally divided into male and female. The Chase (Manchester) has 34 members of staff, who break down as follows: designers – 8 female, 16 male; administration – 7 female, 3 male.

31. Stephen Heller, Design Literacy (Continued): Understanding Graphic Design, Allworth Press, 1999, pp.46–7.

32. Quoted in Tamsin Blanchard, 'A letter you can wear, a dress you can write on', in the Observer, 7 October 2001.

33. Quoted in 'Lavernia, Cienfuegos y Asociados', Novum 04/03, p.33.

34. See Gerald Woods, Philip Thompson and John Williams (eds), Art Without Boundaries: 1950–70, Thames and Hudson, 1972.

35. Beneath an official notice in Kensington Gardens, London, which read 'No skating, No cycling', Howies wrote 'No point living. Howies', in chalk.

36. The other two routes were a comedy character-orientated one and one that used a mix of matte runs (traditionally, an unexposed part of the film – created using a mask – that left a space for other images to be exposed onto it later, although this is now achieved digitally) and live action.